Yeah! I MADE IT MYSELF

Eithne Farry has had a patchwork-quilt career.

A former backing-singer (and tambourinist) with Indie band Talulah Gosh, she is now a freelance reviewer, writer, literary editor and radio personality, who makes most of her own clothes (or at the very least, customises those she buys ready-made in shops).

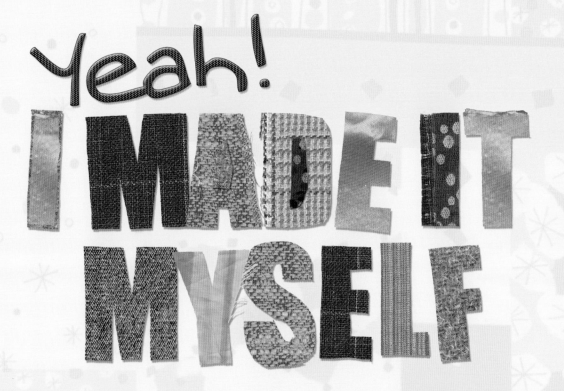

Yeah! I MADE IT MYSELF

EITHNE FARRY

WEIDENFELD & NICOLSON
LONDON

First published in Great Britain in 2006
by Weidenfeld & Nicolson

10 9 8 7 6 5

A CIP catalogue record for this book is available from the British Library

ISBN 978 0 297 85117 2

Design by www.carrstudio.co.uk
Illustration by Ruth Murray
Printed in Italy

Weidenfeld & Nicolson
The Orion Publishing Group Ltd
Orion House
5 Upper Saint Martin's Lane
London, WC2H 9EA
www.orionbooks.co.uk

Mixed Sources
Product group from well-managed forests and other controlled sources
www.fsc.org Cert no. CQ-COC-000012
© 1996 Forest Stewardship Council

Contents

3 Bags In Hand

HOW TO MAKE AN EASY FELT BAG, A BIG BEACH TOTE AND A DRAWSTRING PURSE, A LOVELY OLD LADY SEWING BAG AND A CLUTCH 63

4 Skirting the Issue

HOW TO MAKE A FEW SKIRTS TO RUN FOR THE BUS IN AND ONE THAT YOU CAN'T 83

5 All Dressed Up

HOW TO MAKE A WHOLE HEAP OF GENIUS FROCKS **117**

8 Knit Girls

**HOW TO KNIT LEGWARMERS, ARM GAUNTLETS, A SNUG COLLAR AND
MANY OTHER WOOLLY WONDERS 193**

Epilogue

HOW TO MAKE A DRAUGHT EXCLUDER IN THE SHAPE OF A SAUSAGE DOG IN 17 WEEKS 221

Here's a stitch.
Here's another.
This is a third.
Now make a dress.

Introduction

Some girls have crafty grandmothers; the rest of us learnt to sew at school. Remember those lessons in which it took 17 weeks to make a draught excluder in the shape of a sausage dog, while the person next to you was running up a ball gown complete with boned bodice, ruched full-length skirt and a train? Every time I went back to the sewing machine I couldn't recall exactly how to thread it up, and spent the best part of an hour staring straight ahead with a panicky feeling in the brain area. Once, I was chatting away to my best friend, Sarah, while machine-stitching a pink apron, then stood up to find that I'd carefully tacked it to my grey school A-line skirt. Nice contrast of colours though. So I was more than relieved to abandon domestic science for woodwork, where I could get on with making a cassette rack that was too big to actually hold any cassettes.

But then I fell in love. It was on an August night in North London. The dizzy summer air smelt of petrol and fried onions, and the pavements were aglitter with glass from a smashed bus shelter. There was even a soundtrack: the sweet harmonies of sixties girl groups sha-la-la-ing from a stalled car, its radio blaring out the Ronettes. I came out of the Tube station, and everything in my world changed. The object of my affection? Was it a cool boy in old blue jeans and a handmade T-shirt, the neck sandpapered to give it that hand-me-down air? Or a girl in a thrifted fifties dress carrying a Snoopy lunch box as a handbag? Well, both, and neither. It was *style* that got my wholehearted attention.

Smitten Kitten

I always had *nice* clothes. That evening I was wearing dark-purple cords, a fine-wool lilac jumper and Italian leather boots (purchased with weeks' worth of saved-up Saturday-job money), and I thought I looked good. But when I came out of the Underground and saw the crowd of dressed-up gig-goers sauntering along in outfits they'd imagined for themselves and not just bought on the high street, I knew that's what I wanted to do too. So I went home and cut up most of my clothes in an attempt to make something different out of them. And then I bought some fabric, and set about making a skirt. I didn't know how to make a waistband or put in a zip, so I safety-pinned the long, flowy skirt to the inside of my jumper, and then it fell off when someone stood on the hem as I was getting off the bus. So I learnt a few very basic techniques and made myself a whole new wardrobe.

School sewing lessons had managed to convince me that dressmaking was stress-making, a world of arcane techniques and incomprehensible equipment, where it took months to make something you'd never even want – pelmets for extravagantly swagged curtains, draught excluders (ha!) and hand-smocked baby layettes. I hadn't cottoned on to the fact that it could be all about making unique clothes and having fun while you were doing it.

Now I'm never without a list of things that I'm thinking of making. Here's my current top ten:

❶ A bag in the shape of a cloud (with a silver lining, of course).

❷ A nettle-green dress with swan-white sleeves, inspired by the Hans Christian Andersen fairy tale 'The Wild Swans'.

❸ A dress made out of a sleeping bag. Someone bet me that I couldn't; I said I could. I'm in grave danger of losing £10.

❹ A scarf that looks like a xylophone.

❺ A beach dress that doubles up as a changing tent: summer holidays spent on Irish beaches can be very chilly.

❻ A gown just like the one that Queen Elizabeth I is sporting in the Nicholas Hilliard 'Pelican' portrait. But I might wait until I get a retinue of 27 beaders and seamstresses before I embark on that particular project.

❼ A knitted faux fox-fur stole in coppery mohair.

❽ A crocheted leaf hat in 40 shades of green.

❾ A coat with one huge midnight-blue button, the size of a teacup, to do up at the neck.

❿ A sea-green dress fit for a mermaid.

I'm not a fashion designer, a professional seamstress or even a very patient person, and yet I've been making most of my clothes for years. Mind you, there have been mistakes along the way...

Six Things That I Have Made But Would Never Make Again

A duffel coat in bright-yellow fake fur. It took me an age to sew, and the furry bits kept lining the rims of my eyes, like mini draft excluders. I wore it down the high street. It is sometimes nice to be compared to someone famous, but not if it's Big Bird from Sesame Street. After that, the Big Bird coat stayed on the back of the door, out of sight, until I eventually donated it to a jumble sale. It's probably lining a dog basket right this second.

A matching PVC pinafore and hot pants in forest green with red and gold hearts. The excuse? A sixties fancy-dress party. But I also wore it out to tea with my mum to a family get-together and almost to my boyfriend's cousin's wedding, before I was dissuaded. Excuse? I just really liked them. Sometimes you need to see photographic evidence before you can be persuaded of the wrongness of certain outfits.

A silver trouser suit, inspired by Yootha Joyce in *George and Mildred*, glimpsed on UK Gold. Run up in scratchy lamé, worn out dancing once, consigned to the bottom of the wardrobe for ever.

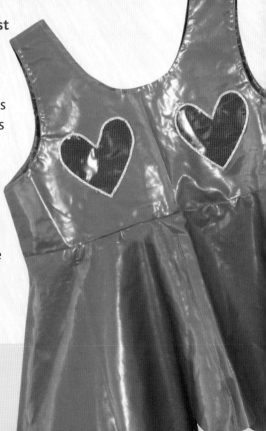

A long pencil skirt that was so tight I couldn't work out how to get my feet up on the platform of the 137 bus. (Now I only make skirts that I can *run* for the bus in...see page 83 for just such a skirt.)

A pair of purple mittens – an all-too-recent mishap. They should have been cute and snugly; instead, they are large and unwieldy, like oven gloves for a giant. I attempted to shrink them by boil-washing them. The mittens stayed the exact same ginormous size, but the colour melted off the sequins I had decorated them with. So now they are giant oven gloves decorated with clear bits of plastic.

They say you should **never knit a jumper for your boyfriend**: it's a bad-luck garment, a potential relationship breaker. I'd add shirts to that cursed list too. Here's the fabric I made it in:

Pretty! He never wore it. Okay, so the collar was wonky, the arms a bit lopsided, and you had to do it up with safety pins because I hadn't learnt how to do buttonholes. But I made the effort, why couldn't he?

It was fun making them though.

I swiftly realised that you didn't have to be technically brilliant or invest huge amounts of your precious time and money to make lovely individual clothes. You just need a bit of confidence, a bit of imagination and some simple DIY skills.

So this book is for anyone who loves the idea of creating their own clothes but is a bit unsure where or how to begin. Just think back to when you were little and you made a wraparound skirt for Sindy with a hanky and a ribbon; well, the same technique can be more or less applied to the grown-up you. Or when you spent a rainy morning making a giant pompom, or knitting a lurid, static, pink acrylic scarf. Remember how thrilling that was, even if you dropped loads of stitches? This book will remind you of all the fun, crafty stuff you already know how to do but have temporarily forgotten, and show you how to put them to stylish use. It'll also teach you how to transform a metre and a half of lovely fabric into a dress that will be the envy of all your friends.

Each project comes with a guidance rating:

One needle – your ten-year-old nephew could make it, no bother.

Two needles – a bit more tricky, but you could still watch TV and finish it without too many mishaps.

Three needles – it's probably best not to attempt this with a hangover.

Audrey Hepburn in Givenchy

My Ever-Changing List of Style Icons

Catherine Deneuve
in *Belle de Jour*

Faye Dunaway
in *Bonnie and Clyde*

Jodie Foster
in *Freaky Friday*

Anne Boleyn

Princess Mononoke

Vivienne Westwood

Joan of Arc

Mad Max (only joking)

Little My from
Tove Jansson's
Moomin books

Penelope Pitstop

Louise Brooks

Edie Sedgwick

Claudette Colbert

Clarice Bean

Margot Ledbetter
from *The Good Life*

Edith Head
(It's true: 'Edith Head
gives good costume'.)

But nothing in here is going to be too difficult for you to get the hang of. I work on the principle if I can do it, anyone can.

And don't worry about being stuck for ideas. There's a world of inspiration out there, from fabrics with gorgeous prints to catwalk photos on the Net. Films, novels and art exhibitions, even the names of fabric can set your creative pulse speeding. How great would it be to make a 'hither and thither' Marimekko coat or 'a little old lady from the North' bag?

But more often than not it's someone glimpsed from a bus window who will have me rushing home to the sewing machine to get started on something new. And you won't believe how proud you'll feel when you sashay out in something you created yourself. I know because there are things that I've made that have made me feel like I've drunk too much coffee, or I am disco dancing inside every time I've worn them. My list of fashion victory clothes would have to include:

My favourite summer dress. Made from a curtain that came from a holiday caravan in Margate, it cost £2.50. Every time I wear it, even on a rainy London day, I feel like I'm at the seaside eating hot doughnuts and heading for a quick paddle.

My Joan of Arc outfit. My friend Elizabeth made one too. We wore them with knitted chain-mail collars and tunics. Accessory of choice? A plastic sword, which I accidentally left behind in the library when I was looking for a biography of Nancy Mitford. I got to the checkout desk and exclaimed, 'Where's my sword?' Luckily, the security guard was on a tea break.

Another dress made from a curtain. This one is shimmery with pale-green and rust leaves. It's the sort of dress that a medieval princess would wear while wandering around a walled garden thinking of unicorns and lutes and frogs.

A brown linen dress speckled with small yellow circles and huge, flappy, kimono-style sleeves. I wear it with a knitted collar and hip decoration, looped with wool and sequins, in a punk geisha styling.

This book is all about revelling in that glowy feeling of accomplishment. What could be better than garnering a bunch of compliments for the skirt you're wearing and being able to say, 'Thanks. Yeah, I made it myself'?

Stocks and Sharesies

What you need and why you need it

If you ever peek inside sewing manuals, the opening pages are bursting with items that you need to own before you can even think about running up a frock. I own practically none of those things, even though I've been making my own clothes for years. In fact, there are some things in there that I have never even seen in real life – rouleau loop turner, plastic point turner, complex French curve – let alone used. The first proper thing I made (after my falling-off-skirt disaster) was a sleeveless summer dress. It didn't have a zip or buttons, but it did have pleats – to get it on, you just pulled it over your head. I had a pair of bad scissors, a needle and thread, and some pins. Nowadays I have a pair of *good* scissors (I still have the old ones, but every time I try to cut with them I'm reminded how much harder everything is with a bad edge!), a sewing machine, an iron, a tape measure, pins and some dressmaking patterns...and that's pretty much it.

Add in heaps of nicely coloured thread, a couple of zips, lots of trimmings, some chalk and a jar of buttons and you have my sewing kit. I also possess a fabric mountain, because I can't resist the lure of material shops, charity shops and car-boot sales, but you don't have to go down that covetous route.

What You Need to Get Started

So, as far as essential stocks go, you'll need:

■ **A big pair of good scissors.** Really, don't skimp on these – cutting fabric is so much easier with a good blade.

■ **A small pair of sharp scissors.** For trimming seams and snipping threads.

■ **Pins.** New ones, because old ones can get rusty and leave marks on your fabric.

■ **Hand-sewing needles.** For tacking, stitching some pretty embroidery onto the flap of a pocket, or threading sequins onto your home-spun hand-felted corsage. Add a big darning needle to your pincushion too; they are just the thing for sewing up the

seams of your newly knitted legwarmers. Most haberdasheries will sell assorted packs; pound shops also have them.

- **A tape measure.** I tried using one that came out of a Christmas cracker, but it was too stretchy. I kept it because I liked the colour (greeny-blue), and went back to using my old plastic-coated one, which has no 'give'. They cost about £2.

- **A ruler.** For drawing straight lines.

- **A seam ripper.** Otherwise known as a quick unpick. It's a fact of life that things can go haywire. This little gadget undoes a cranky seam or a crooked hem in seconds. Price? About £1.50.

- **Tailor's chalk.** To mark up the fabric with. When I first started sewing, I grabbed the first thing to hand, a felt pen. I thought the big, bold line would be straightforward to follow. And it was, but it also seeped through the thin cotton of my dress, and looked like a pen accident that wouldn't wash off. Now I use tailor's chalk, which brushes off the fabric easily with a quick swipe of the hand.

- **I LOVE...thimbles.** I never use them, but I love them anyway.

- **An iron.** It doesn't have to be top of the range, an OK one will do, but it should have a good steam function: you'll be amazed at the difference a little judicious pressing can make. Wonky stitches will become straight; fabric will be wrinkle-free and easier to sew.

And ...

◆ **A sewing machine.** You can, of course, hand-sew stuff, but it takes AGES to finish anything major, like a dress. I used to work with a girl who hand-sewed her boyfriend's shirts from start to finish. I admired her stitches, which took weeks, but secretly I thought, 'You're a loon.'

OK, so buying a machine can be a bit of an investment. You might want to borrow one, or go into partnership with a friend and share the cost. Think about what you want to do with it. If you're just planning to stick to 'sewing two pieces of fabric together', you can purchase a basic model, but if you're contemplating embroidery, quilting and the like, that's going to be more expensive. Department stores and sewing centres will be able to give you advice, let you try out the machines, and tell you exactly what they can do, before you decide to purchase.

If your intention is to run up a summer wardrobe using lovely lightweight cottons, you can buy a very basic machine for about £100. If you think you may want to include some fancy stitching, a bit of embroidery and more robust fabric, expect to pay over £250. But if you're embarking on curtains, cushions, re-covering the settee, plus running up a winter coat in heavy-duty wool, you're going to need a machine that can deal with upholstery fabric and has a variety of different stitches. Starting price for this level of sophistication? £400. That said, I went sharesies with my sister years ago (she got married, I kept the machine), and even now I still haven't used half the functions on it.

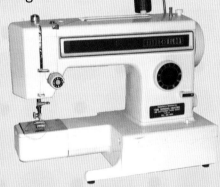

You could buy one second-hand, and charity shops often have them for sale... which is fine if they work, but sometimes the instruction manuals are missing, which can be tricky.

For advice on sussing out your sewing machine, see page 40.

◆ **Machine needles.** Different fabrics need different machine needles – e.g. fine fabrics like lawn, chiffon and organdie need a small sharp-point needle. Slinky stuff like Lycra needs a specially coated stretch needle. It's too dull to go into here – look on the needle packet. You'll be glad you did.

◆ **Thread.** Thread alert! Ideally, the type of thread you use should be the same as the fabric you've gone for – cotton thread for natural fibres, polyester for man-made fibres, silk for silk. And it's always a good idea to bring a snippet of your chosen fabric along to the shop to match up the thread colour. Choose an ever-so-slightly darker shade than your material, if you want the thread to blend in. Or if you want to make a feature of the stitching, choose a contrasting colour.

◆ **A few simple patterns.** You can make loads of things without patterns, but for complicated garments, they're pretty handy. You could learn to draw your own, but it's a lot like hard work...too much for a girl in a hurry like me. That's where commercial patterns come in. They're drawn on big sheets of *café-au-lait*-coloured tissue paper, and they come with sewing instructions. All you have to do is cut the pieces out. If you find one you like, you can use it over and over again.

Ages ago I bought an easy-to-sew A-line dress pattern, with bust darts and a back zip, and I use it all the time (for the pattern, see page 131). I like the nice jutty-out

angle when it's made in a stiff fabric, or how soft it is when I make it in a floaty fabric. And you can change the look by adapting the neckline and sewing on a different kind of sleeve. At the beginning it took me a couple of days to make the dress, but now I can run one up in a few hours. I ditch many of the pattern's sewing suggestions – I'm mostly too lazy to use interfacing (I'll explain what that is in a minute), even though it would give the dress a more professional look. And most days I don't bother finishing off the sleeves or neck properly either – I just sew a length of bias binding around the zigzagged edges, zip up, and hope for the best.

Your local fabric shop or big department store will stock a variety of pattern catalogues, including McCall's, New Look, Vogue, Butterick and Simplicity. Don't be put off by the photographs or sketches, which quite often look like nothing you'd ever want to wear. The trick is to imagine them in the fabric of your choice, magic away that sprigged pink cotton, and replace it with a bold geometric print. (This rule does not apply to jackets with huge padded shoulders; it doesn't matter what material you're thinking of making it in, it is NEVER going to look any better than the illustration, even if eighties power-dressing comes back, and even if it's ironic.)

TOP TIP Look out for sales and special offers. Pattern prices can be reduced by as much as half for a limited period.

Pick easy-to-sew patterns at first. They'll be straightforward, with no difficult techniques to master. The back of the pattern envelope will tell you how much fabric you need, the length of zip to buy and any other bits and pieces you might need to finish your garment. This info is in the 'notions' bit, and might list things like buttons, hooks and eyes, ribbon or trimmings.

Or you can just do your own thing, take the scissors to the fabric, and start snipping.

◆ **A few bits of interfacing.** This is a special kind of fabric that adds strength and shape to collars and cuffs, button bands and waistbands. It comes in different weights (light, medium and heavy) to match the type of fabric you're using, and it can be ironed on or sewn in. I usually go for the iron-on version. It's stocked in the haberdashery department, and comes on a roll. You can buy as little as 10cm, or as much as you want.

◆ **Some bias binding.** I LOVE bias binding. This is a strip of fabric that is used to give a neat look to raw edges. It comes in loads of different colours, is brilliant for finishing off hems neatly, and makes a dress or a sleeve look really pretty. If you're feeling very fashion flash, you could always use seam binding on the inside of a coat or jacket – a thin band of colour on every seam looks lovely. I've been told that you can make bias binding yourself very easily...but I never have.

That's pretty much it on the sewing equipment front. So let's go shopping for fabric...

◆ **Fabric.** The needle noodling above probably gives you the impression that I am constantly running things up in exotic crêpe de Chine or devoré velvet, and adding big organza bows. I'm not. But the truth is that your fabric choice is THE MOST IMPORTANT THING when it comes to making anything. If you get the right fabric, that's 90% of the work done, and it doesn't have to cost earth-shattering amounts of money. Big, bold patterns make for statement summer dresses; a metre of a joyous Liberty print turns a simple top into a thing of beauty; a length of forest-green canvas transforms a drab coat pattern into the kind of coat that'll put a spring in your step every time you wear it; a wraparound frock made in plain dark-blue cotton is practical, but the same wraparound dress made in glazed cotton printed with dusky-pink peonies is fit for a princess. You can see where this is going – by picking imaginative, unusual fabric, you can make even the simplest outfit look good and stand out from the crowd.

I make a lot of things in all kinds of affordable cotton – from crisp curtain material, which is great for sixties-style frocks to the soft, floppy stuff that quilters use in their craft projects, which can be made into delicate, cool summer dresses or tops. I like wool, and linen, and weird sparkly stuff, and velvet, and small squares of felt, and fabric with big, coloured spots dotted on it. I like all kinds of everything in the world of fabric, but I stick (mostly) to a couple of rules: I try not to buy anything that needs to be dry-cleaned, 30–40 degrees cool wash is the kind of care instruction that I like to see on the end of a bolt of cloth; and I like to stick to the £15/m mark on the cost front. In fact, usually I like to stick to well under the £15/m mark...because then if it does go wrong, I won't have wasted a fortune. It takes a particular

kind of courage to cut into a beautiful, expensive piece of cloth. My friend Lesley, who can fine-tune tailored suits, bone corsets and rustle up any number of complicated geometrical garments, has three pieces of the most luscious Chinese silk – the colours are so rich that they glow when you look at them. But she can never bring herself to cut into them. Too scary. She says, 'But what if I make a mistake?' In most circumstances, I'd take the punk-rock stance and get the scissors out, but I understand her hesitation here: the silk is just too lovely to ruin.

Which is why I get my fabric fix at a much cheaper price. I get stuff from local shops and markets, which often have lovely sari material or batik prints from Africa and Asia, or from department stores. (I'm still searching for a design that I saw in a photograph at the National Portrait Gallery. It was a family group – a husband and his three wives – all smiling for the camera. One of the women was wearing a dress made out of a fabric named 'The jealous eyes of my husband's second wife'. The exhibition was called 'You Look Beautiful Like That', and was made up of the studio portraits of Malick Sidibé and Seydou Keita.)

To be honest, some of the choices in the dressmaking section can be on the bland side, so I head into the furnishing fabrics instead. John Lewis is good – lots of their in-house curtain designs have a lovely vibrant look about them. Ikea does quirky upholstery material that you can bung in the washing machine. And head for the Designers Guild and Liberty at sale time, when there are many bargains to be had. Dressmaking and furnishing fabric usually comes in two different widths – 115cm or 150cm – and in most shops the smallest amount you can buy is a 10–20cm-long strip.

Most fabrics bought from dressmaking departments are pre-shrunk (do check, just to be on the safe side), but curtain material and the like won't be, so buy a little more to allow for that shrinking potential. The same goes for craft fabrics, so give them a cool wash before you turn them into a fitted frock, and there'll be no 'it was fine before it went on the washing line and now it's too tight'-type shocks. Most of the clothes and bags in this book have been run up in the 150cm-wide variety, so if you buy off a narrower bolt, it's a good idea to add on a little extra.

Iced-gem colours, sophisticated lady prints, silly, pretty cartoon horses – there's so much fabric to choose from, so have a good wander around, and see what's out there. Add to your shopping basket ribbons, and sequins, and feathers, and beads, and buttons. You can never have too many buttons so...

◆ **A button jar.** My button jar is one of my favourite things. I started off by snipping lovely buttons from grotty cardies that I thought were nice in the jumble sale but realised were hideous when the bargain fever had cooled down. Charity shops often have huge tins of stray buttons stashed away; buy a few at a time for just a few pence. And head for haberdashery departments for more expensive treats. Lonely buttons are lovely: you can mix and match them on a coat for that home-spun look, or add them to charm bracelets or knitted cuffs as a quirky detail. Buttons look brilliant on knitted belts, big cotton totes, small clutch evening bags and sprawling bower-bird necklaces – in fact, most things look even better with a button or two or five. And even if you never sew a button onto anything, they're nice to look at on a dreary winter's day. Tip out the jar, and scatter your treasure over the table...see, suddenly things aren't so grey.

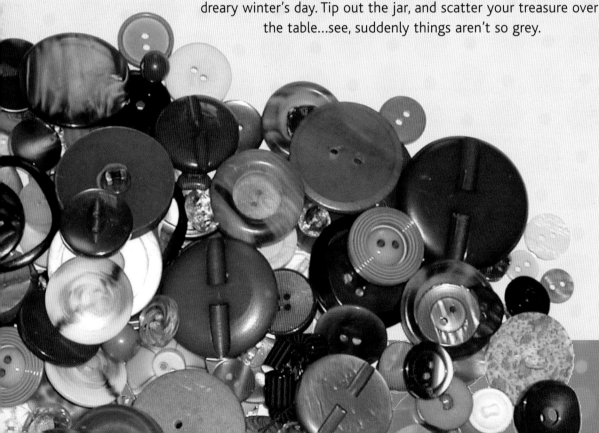

But don't be afraid of **colour**. I might occasionally make a little black dress or skirt, but not often. I like bright, shiny things too much to be smitten only by *noir*. And it's more than fine to experiment – try out odd combinations of colours or textures: often you'll find they look just lovely (for ideas on how to design your own patterned fabric, see pages 147–150). The teeniest bit of Cath Kidston fifties-look flower print can be turned into a corsage in minutes, and pinned to a glittery, snail-patterned, sleeveless dress. Or make a sage-green shirt, and team it up with a plum skirt and turquoise knitted belt decorated with little silver bells. It's all about playing around and having FUN.

It doesn't matter if it isn't absolutely flawless: imperfection's more interesting.

Stitched Up

All you need to know to get started

OK, so you've got your stocks and sharesies in hand, now all you need are a few simple techniques to get you going. Actually, hang on, before reading this chapter, head up to your wardrobe and gather together a small bundle of your favourite clothes. Imagine that you are seven and about to run away from home for the first time – everything you pack has got to be pretty and practical, but then add in a few little extras, like a lovely old scarf, discovered in a country charity shop (if you are handy with knots, this could be your travelling knapsack), or a short velvet cape, in case your new life involves eating out in theatrical restaurants. Include a summer dress, a couple of skirts and a few tops. (If you are really running away, don't forget many spare pairs of knickers.) Snuggle up somewhere really comfortable, and then turn all the carefully chosen clothes inside out.

Have a good look at the way they all fit together. Look at the seams, the hem, the zip, the way the edges are finished off and the look of the button and the buttonhole. This is the best way of seeing the outcome of applying the techie details in this chapter. Reading about hems suddenly makes much more sense if you've actually got a hem in front of you to give you vital 'ah-ha' clues. And it's a really, really good idea to have some scraps of fabric on hand to practise the techniques as you go along.

A Couple of Basic Stitches That You Can Do by Hand

Running Stitch

Running stitch looks like a series of small, even dashes, and is great for gathering fabric – – – . Put a knot in the end of your thread, work the tip of your needle in and out of the fabric a few times, and then pull it through. You can keep the stitches small and neat, or make them longer for tacking (aka basting) — — —. Tacking is a row of long running stitches which hold the fabric in position before you sew everything together for good. It stops the fabric from slipping out of place when you're machine-sewing, and if you tack at each stage of dressmaking, you can see how things are looking and tweak until you're happy. **It's good to tack.** Knot the thread at the beginning, tack along the cloth, leave the end of the thread loose and easy. Once you've finished the machine-sewing, snip the knot, and pull the tacking stitches out.

Back Stitch

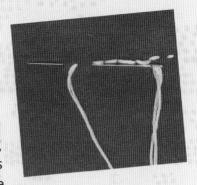

Back stitch is a handy little thing. You use it for sewing the seams when you're making a bit of clothing. It looks pretty ugly on one side of your work, and pretty pretty on the other. Make one stitch, and then bring the needle up through the fabric to begin the next stitch. Then put the needle back into the fabric at the end of the last stitch. Bring the needle out again, going forward again but further this time, making the gap the same size as one stitch. Put the needle back into the fabric where the last stitch ended, bring the needle out further along. Keep inserting the needle at the end of the last stitch and bringing it out one stitch ahead. That's back stitch done and dusted.

If you happen to have on hand some of that lovely school stuff, pale blue or dark blue, woven with big square holes for practising embroidery on, you could use that for trying out running stitch and back stitch. Or have a quick look around in pound shops. Often they have cheap little tapestry sets. Ditch the herbaceous border transfer that comes with the kit, and use the holey fabric to make cuffs stitched with cheeky mottos, and then sew them onto the ends of sleeves. Or if you cut it into a long strip, it could be become a cross-stitch belt embellished with one of your favourite quotes from a book, from a film or from one of your friends who has an eloquent and snappy way with words. My favourite sayings at the moment are a text message from my friend Dern, sent while he was failing to meet simultaneous appointments, 'I am sandwiched between two geographically opposed men,' and the motto 'We're not even going to try' from an obscure Indie band who wore big quiffed wigs and mustachios.

Machine Dreams (and Nightmares)

Before you get into the sewing-machine stitches, it's best to get to grips with the machine itself.

The first rule of sewing is DON'T FEAR THE SEWING MACHINE.

It's easily done. In your head is a glorious vision of the perfect party dress, made up in drifty rose-petal silk and spangled with sequins, but in front of you is some mechanical contraption with dials and knobs and incomprehensible metal bits. It is tempting to bunch the silk fabric up in a ball and stuff it behind the sofa, put the cover back on the sewing machine, and head out to the shops to *buy* something to wear to Lancelot's leaving do. But DON'T!

Although I can't give you the low-down on the individual quirks of your machine, I can tell you that all machines pretty much work the same way and that once you get going it's all pretty straightforward. Really! For starters, don't ignore the manual that comes with the machine. It may initially induce feelings of panicky boredom when you flick through the pages, but hidden in all that tech talk of bobbin winder discs and top thread tension control, there's the stuff that really counts, like how to set up the machine so that you can get the sewing party started. Prop the manual next to the sewing machine, grab those odds and ends of fabric and thread, and as you're reading the instructions, put them immediately into action.

Here's a picture of my sewing machine and a few words of explanation:

Presser foot thumb screw

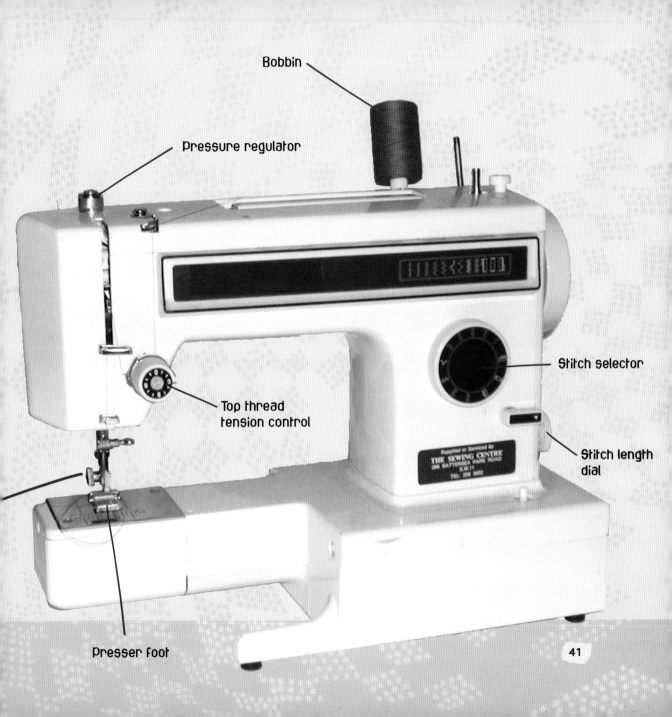

Bobbin

Pressure regulator

Stitch selector

Top thread
tension control

Stitch length
dial

Presser foot

Some General Machine Dos and Don'ts

- DO check that the machine is correctly threaded up.
- DON'T go too quickly at first.
- DO make sure that you have two lots of thread on the go: one for the needle and one for the bobbin. It's the interaction between these two strands that makes up the stitches.
- DON'T use really, really cheap thread. It gets very knotty very quickly.
- DO make sure that you're using the same type of thread in the needle and on the bobbin.
- DON'T bother to try and unravel that huge bird's nest of thread that's nested in the bobbin case. Just snip it off, chuck the snarled-up hank in the bin, and rethread the machine.
- DO check to see if the thread is wound smoothly onto the bobbin. If it isn't, unravel it (salvage that for hand-sewing), and rethread that bobbin.
- DON'T let lint and fuzziness and dust build up on the insides of the machine. A quick dust every now and then can save you many long-term hassles.
- DO replace the needle every few months. The metal can get a bit shonky and worn out from overuse and start misbehaving.

All OK? Have a go at sewing with it now. Just mess around and see what happens.

Mishaps, Mistakes and Other Machine-Based Snarl-Ups

Things inevitably go wrong, but you can turn the wrongs into rights by running through this quick check list:

▼ Is the machine threaded correctly?

▼ Is the bobbin in its proper place?

▼ Is there enough thread on it?

▼ If the thread keeps breaking, look to see if there's a knot somewhere. If not, it could be the needle that's causing the problem.

▼ Is the needle in the right way? Make sure it's not bent out of shape; if it is, replace it. If the needle keeps snapping, check you're not using too fine a needle for the fabric you're working with.

▼ Has the pressure foot worked itself loose? Tighten it by twisting the knob at the side. (Have another look at the sewing-machine picture on page 41 to remind yourself of where this is.)

▼ For medium fabrics, like cotton, the pressure regulator should be about halfway down. If you're using hefty fabric, or sewing lots of things together at once, release the pressure. Flimsy fabric will need more, so press the pin down.

▼ Check your tension. Different fabrics need different tensions. If the thread is too tight, your sewing will pucker up. If it's too loose, your stitches will be slack. Adjust the tension by turning the tension disc on the machine — if the upper thread is too tight, decrease the tension; if it is too loose, increase it. While you're at it, check your stitch length.

▼ If all that still hasn't sorted out the problem, it could be that the bobbin thread needs adjusting. Pop the bobbin case out of the machine, hold it by the thread, and give the whole thing a quick jerk. If things are as they should be, the thread will unwind a few centimetres or so. If the tension's too loose, you'll end up with a spool of thread around your feet; if it's too tight, it won't move at all. With a small screwdriver make tiny adjustments to the screw on the bobbin case...to increase, turn clockwise; to decrease, turn anticlockwise. Keep doing the jerk until you've got it just right.

None of the above? Your guess is as good as mine.

The Stitches That You'll Mostly Use on the Sewing Machine

Straight Stitch

Most machine-sewing is done with straight stitch. All you need to do is turn the machine dial to the straight stitch, adjust the stitch length, and away you go. Put in a few reverse straight stitches at the start and that will stop your sewing from coming unravelled. Flick the reverse switch and hold, put your foot down on the machine pedal, sew, release the switch, and then go right ahead with a lovely row of straight stitches. You can also tack (machine-baste): set the stitch length to its longest option, make the tension a little looser than usual, and then just sew.

The Invaluable Zigzag Stitch

I nearly always zigzag the raw edges of the fabric before I sew it all together into a dress or a skirt. It looks very pretty, and it stops the fabric from unravelling. I never used to bother – I'd just sew and go, impatient to give my brand-new outfit an immediate airing, which was fine for a day or two or three, until the fabric started to fray and neatly sewn seams began to unravel. My mum always made me do a little pirouette before I left the house in my latest outfit. She wasn't just admiring the beauty of my new creation. More often, it was to snip away at dangling threads and little fringes of droopy fabric that were disgracing my hemline. But now that I've got into the zigzag habit, disintegration is a thing of the past. Set the machine dial to zigzag. Sew as close to the fabric edge as possible. If you were a skier and magically shrunk, these stitches would look like mountains regulated by the EU – perfect thready peaks.

To add a distressed, aristocratic edge to a brocade dress or a delicate silk skirt, you can leave the hem to gently fray and unravel. To stop the dress disintegrating entirely, sew a line of zigzag stitches a little way in from the edge...there's something very appealing about this unfinished look. You could do the same thing at the neckline. Your dress will look threadbare and very pretty.

Now you're ready to make a belt.

A Ribbon Belt

- Zigzag the raw edges at the end of the ribbon.
- Fold the ribbon in half. Sew the halves together all the way along the outer edges.
- Place the D-rings on top of each other about 3cm from one end of the grosgrain ribbon.
- Thread the end of the ribbon through the D-ring loops with the curved bits of the D-rings facing outwards. Fold it back 2cm, and stitch in place.
- Wear the belt immediately.

And you can always swap the grosgrain ribbon for a length of striped elastic.

ONE NEEDLE

- 1 x 220cm-long, 4cm-wide strip of stripey grosgrain ribbon (if you like stripes, and I do) or Petersham ribbon (You can use narrower ribbon and smaller D-rings, or wider ribbon and bigger D-rings.)
- 2 x 4cm D-rings (a metal ring used to join straps, which cost about 30p each from haberdashery departments. Not to be confused with the D Ring – the innermost ring of Saturn and, apparently, very faint indeed.)

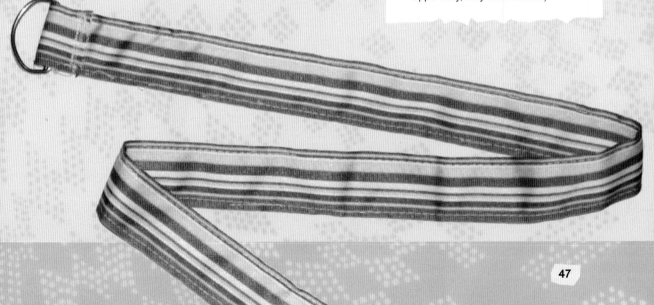

Pressing, Seams, Hems and Cutting

Pressing Matters

Even if you abhor ironing and truly believe that crinkles and wrinkles equals shabby chic, a good press at every stage of the proceedings will make a world of difference. This is one of the sewing rules that I always scoffed at, until, that is, I actually tried it out for myself – crooked stitches disappeared, and seams and hems were miraculously elegant. For best results, use an ironing board. Remove all pins and tacking – if you leave them in, they'll leave marks on your lovely fabric. Adjust the dial on the iron according to the type of fabric you are using. Press down on the wrong side of the fabric to avoid that weird over-ironed shiny look (not something I'm overly familiar with). Try not to let the iron glide! A steady lifting and lowering of the iron is the action you should be aiming for. And definitely don't go for the burn.

PS. There *are* many days when I get lazy or hasty and leave the iron unplugged, and things are just fine, but I know that they'd be finer still if I had applied a little steam.

Seams

There are many kinds of seams out there, but the plain seam is the one you'll use the most. All this involves is sewing the right sides of the fabric together a little bit in from the edges. That little distance in from the edges is known as the seam allowance.

Most commercial patterns have a seam allowance of 1.5cm, but you can get away with 1cm if you're making up your own patterns, and that's the measurement I've mostly used in *Yeah, I Made It Myself*.

Do the zigzag thing first, then if you're feeling doubtful, pin 1cm in from the edge all the way up the seam, and tack up the seam (see picture). Once you're satisfied that everything is as it should be, whip out the pins, and machine-stitch the seam. If you're confident and/or hasty, throw caution to the wind and bypass the tacking and even the pinning, machine-sew, and go right ahead to the pressing bit.

The first thing to do is to press along the stitching line. Almost instantly the machine stitches will merge with the fabric in a very professional manner. Then, open the seam up flat with the tip of the iron, and get lifting and lowering. Your seams will now be svelte and lovely, not lumpy and bumpy.

Hems

The office stationery cupboard can always supply essential items for a raggedy-hem repair. Staple the hem back in place, making sure the sharp bits of the staple are on the inside, then stick a strip of masking tape over the back of the staples to avoid any nasty snags or scrapes. You could bypass the staples altogether and go straight for masking tape, but a metal glint along the bottom of a skirt is quite a nice finishing feature. You could use Wundaweb – this is an iron-on tape that secures a hem in seconds. Fold the hem, insert the Wundaweb, press, *et voilà*, hem finished, no sewing. Or get busy with a squirt of fabric glue. Either of these no-sew methods are OK when making something from scratch, but it's always good to have some more tricks up your sleeve.

Take advantage of that handy woven strip that runs lengthways along the edge of the fabric. It's called the selvedge, and it won't ravel or fray, so it's perfect to use as the hem. You can leave it as it is, to save sewing time, or turn 1–2cm to the wrong side, and then sew it. You can also cut the dress or skirt to the exact right length, zigzag the edge, and hide it with a length of bright binding or ribbon, folded over, and neatly sewn.

You may have noticed that the hems and seams of high-street skirts and dresses are finished with an intricate row of close-together stitches. These are done with a special machine called an overlocker, but you don't need to bother about that, instead go for...

The cheating hem

The one I use almost ALL OF THE TIME. It's speedy and easy, and this is how you do it:

- Decide on the length of your frock; cut the material to a bit longer than that length.
- Tidy the edge with nice little zigzags.
- Turn the edge under to the wrong side, and then sew it with a nice straight stitch. Press.

It doesn't have to be a skinny little hem – you can turn under 2–3cm – but don't turn under too much or the hem will start flapping down. To make the stitches less noticeable, choose a thread colour that blends in with the fabric, but if you want to make the stitches stand out, use a nice bright contrasting shade. And don't feel you have to limit yourself to one line of stitches, add two or three or four more rows.

If I'm in a real hurry to wear the dress, I turn a little hem under, and I zigzag it in place. Advantage? Fast. Disadvantage? The zigzags will be fairly obvious along the hem, but I think that looks kind of pretty. And eventually the hem will get a bit raggedy-looking.

The neat hem

For drifty fabrics, or a neater finish on all fabrics, use this method:

- Decide on the length of your dress, skirt or top, and add a bit extra – about 3cm – to the length.
- Zigzag the raw edge.
- Turn the hem 1cm over to the wrong side, and press, then fold it over again, press it, straight-stitch it, and then press again.

The hand-stitched hem

The hand-stitched hem takes a long time, but you (hopefully) won't be able to see the stitches on the front of your frock.

- Zigzag the fraying edge.
- Turn the hem 1cm to the wrong side, and press, fold it over again, and press again.
- Thread up your needle, and do a little back stitch on the flap of the hem.
- With the point of the needle, pick up a couple of threads of the fabric right next to the folded edge. Push the needle diagonally through the fold of the hem, and pull through.
- Move a little to the left, pick up another couple of threads of the fabric, and repeat all of the steps above all the way along the hem, in nice, evenly spaced stitches.
- And don't stitch them too tightly, or the hem will look scrunched up.

That's pretty much all you need to get started on the practical side. There are a few more handy little things to know, like how to sew darts, put in zips and make buttonholes, but you can get to them when you're good and ready in Chapters Four and Seven.

Cutting

Make sure your fabric's got no rucks and tucks before you start to cut, because once you cut, there's NO turning back. Wrinkly fabric will result in an askew garment. (Sometimes this works as a maverick fashion innovation, but usually it just looks like you went wrong somewhere along the way.) And always cut on the grain of the fabric: this makes it easy to sew, and the end results won't be lumpy and bumpy, and will hang beautifully.

Going with the grain

A small confession. Every time I *think* about the grain in a piece of fabric my mind gets a bit befuddled. It's probably because I can never quite recall how the horizontal and vertical thing works. And words like weft and warp and woven and loom send me right back to the Industrial Revolution and history lessons on a hot, sunny day. But somehow if I'm *looking* at a couple of metres of fabric, it all makes instinctive sense. It will to you as well, honest.

The grain is the direction the threads in the fabric run (see picture). The woven border, which won't fray or ravel, is the selvedge. The threads that run parallel to this are called the lengthwise grain, and they are very strong and dependable (like Cary Grant).

The crosswise grain runs across the width of the fabric from selvedge to selvedge. There's another thing to know about grain, and that's to do with

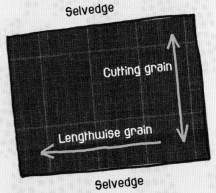

Selvedge

Cutting grain

Lengthwise grain

Selvedge

true bias (see picture). True bias is the perfect diagonal across the fabric forming a 45-degree angle to the selvedge, and this has the most stretch and elasticity. Dresses cut on the bias look fluid and flowing, and have the slinky appeal of Jean Harlow's evening gowns from the thirties. On the downside, bias-cut stuff uses more material, and they're trickier to sew, so maybe work on a few easier things first.

Commercial patterns clearly show the way to lay out the pattern pieces on the fabric. Don't buy LESS fabric than it suggests on the pattern envelope and then attempt to squeeze everything in higgledy-piggledy. You might have saved yourself a pound or two, but when it comes to sewing it together, chances are the skirt will flare on one side and not on the other, and the hem will be lopsided, and you'll be thoroughly disheartened. So, tempting as it is to just start cutting any old how, it really is better to go with the grain of your fabric. Follow the layout guidelines and all the pieces will fit together beautifully.

Save any leftover scraps of fabric: these can be transformed into a petite drawstring bag, perfect for popping party make-up into. Or sewn into a rosette to grace the waist of your favourite dress, or scrunched up into flowers and stitched to a silk cord to make a necklace. Or make the snippets into fabric beads — just wrap the scrap of fabric around a cotton ball and hand-stitch it in place. Make lots of them, in different colours and patterns, and get a length of suede cord, and sew the beads onto it. If you've got loads of leftovers, you could even patchwork them into something lovely, like a small shrug for chilly autumn evenings.

A Bit More About Fabric

I'm pretty much a let's-see-what-happens-if-I-try-and-make-a-raincoat-out-of-shower-curtain-material kind of girl, but there are a few necessities to bear in mind when you're starting out. Avoid buying fabric with really obvious diagonals, as they are the devil's own to try and match up. But don't be dismayed by stripes and checks. They may seem a bit fiddly at first, but really it's the same principle as wallpaper: a bit of shuffling around and it all falls into place. And just like wallpaper, you always have to buy extra to match the print up. The same applies to big, bold patterns, but I never bother to make sure everything's perfectly – or even vaguely – matched up, so just go right ahead and ignore that bit of advice if you want to.

Fabrics with a pile, such as velvet, corduroy and fake fur, look lighter one way up than the other, so when you're cutting them out, all the pattern pieces must go in the same direction on the fabric. To get the richest, juiciest look on a velvet dress, the pile should run upwards from the hem to the neckline. Stroke your hand along the length of the fabric: if you're going the wrong way, it'll be like a kitten's raspy tongue; if you're smoothing it the right way, it will be just like, well, velvet. Put a safety pin at the top to remind you which way is up.

Sheer fabrics, like chiffon and lace, can be tricky to sew with, as they're slippery and fine, so take it slowly. Or use something else. Life's too short to fuss.

Before You Start

A few suggestions:

✳ Be realistic about time – don't kid yourself that your spring capsule wardrobe, inspired by Catherine Deneuve couture in *Belle de Jour*, can be made in four hours flat. It can't. (That nice big tote and matching beach skirt with the drawstring waist, on the other hand, can – see pages 71 and 93.) Studying the pattern, cutting and pinning should be done at a leisurely pace. Allow extra time if you're trying something new, like pleats or buttonholes.

✳ Are you sitting comfortably? This may sound like a no-brainer, but I usually sew on the floor, which would be fine if I remembered the perfect posture pose, but I don't, and end up hunched over the sewing machine like a princess in a fairy tale trying to spin gold from straw. Result? Pretty frock, bad back.

✳ Don't keep knitting or sewing if it's starting to feel stressy. I usually go outside to look at the trees (I always think that their winter silhouettes would look beautiful stencilled or printed onto a skirt or bag), buy a bag of penny shrimps, eat them, and then head back. It's not an exam; you do not have to finish it ALL right now. In fact, things are likely to get a little wonky if you sew on past your own personal concentration level. Avoid those lose-lose situations. If it's starting to go wrong, stand up, put a record on, and jump around the room, then go back to the needle and thread. But only if you feel like it.

Oh, a Quick Note Before You Get Going...

If you're unsure of your size, cut generously. Too big and it can be taken in. Too small and you will be the proud owner of yet another lovely cushion cover.

As I mentioned before, most of the clothes and bags in *Yeah, I Made It Myself* have been run up in fabric that's 150cm wide, so if you buy off a narrower bolt, remember to buy 40cm extra.

The skirts and dresses are measured out for a loose size 12. Add an extra centimetre for every dress size you go up; subtract a centimetre each time to make smaller sizes, when you get to the cutting-out stage.

Throughout the book, in the amount of fabric that you'll need for each thing, I've put the width first and the length second – e.g. 120cm x 180cm.

When I say 'fold in half lengthways', I mean this:

When I say 'fold in half widthways', I mean this:

Get snipping.

A Sixties Cartoon Dress

(ONE NEEDLE)
- 120cm x 90cm of felt
- About 50cm of Velcro or a row of big, brass poppers
- 1 roll of coloured gaffer tape

My friend Amy, who is a singer in a band, has a dress that looks like it is held together by the kind of insulating tape roadies use to do on-the-spot repairs to microphone stands and electric cables. Her frock is made in biscuit-colour felted wool, and its sticky-out A-line shape is a homage to all things Courrèges and Cardin. Closer inspection reveals that it is sewn but in the simplest way possible and there's no zip; instead, it's fastened with a row of big, brass snaps, or poppers. It's easy to make something similar with a metre and a bit of fabric that doesn't fray, like felt, and a roll of brightly coloured gaffer tape for decorative purposes. (Buy it in hardware stores; it mostly comes in black and silver, but I have seen it on the Net in oodles of different colours for about £2.50 a roll.) If snaps don't appeal, use Velcro instead, and buy the stick-on version to cut down on the making time. This dress also needs a soundtrack. I suggest a girl-group compilation tape to provide handclaps, harmonies and songs about 'he's so fine' boyfriends and falling in love with the leader of a local motorcycle gang. (Your mum was right: he was a heartbreak waiting to happen.) So here it is, a little minimum-sew dress to get you started – definitely not designed to last a lifetime.

You can make this in about an hour and a half. (False eyelashes and a guitar-strumming boyfriend strictly optional.)

- Fold the felt in half lengthways, and cut out a dress shape just like the one in the picture right.
- Cut a 'V' in one of the pieces at the neck, or a scoop if you prefer a more rounded look; this is going to be the front of the frock.
- Cut the other piece in half; this is the back.
- Pin the two back pieces to the front at the shoulder and at the sides.
- Try it on, and see what you think.
- If you're happy with its sticky-out grace, sew it all together, using a 1cm seam.
- If you're not happy with the fit, re-pin until you are, and then get stitching. There's no need to zigzag, as the felt won't fray, so that makes things speedy.
- Now for the back. Don't do the usual kind of seam at the back; instead, overlap one centre back piece over the other, and pin it all the way down.
- Don't sew it in place from the top though; from the neck edge, leave about 44–46cm unstitched. This is where the Velcro (or a row of big, round poppers) will go.
- Stitch the back in place just below that 44–46cm opening.
- Take out all the pins, and stick the Velcro in, or sew the poppers in place.

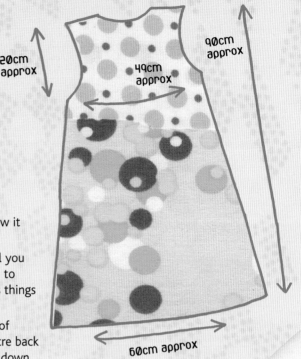

20cm approx

49cm approx

90cm approx

60cm approx

That's the dress done. Now all you need to decide is where the gaffer tape should go. A couple of stripes down the middle and at the shoulders looks good. And don't neglect the back – you can stick (or machine stitch) a strip down the back centre, or add a row of tape along the hem.

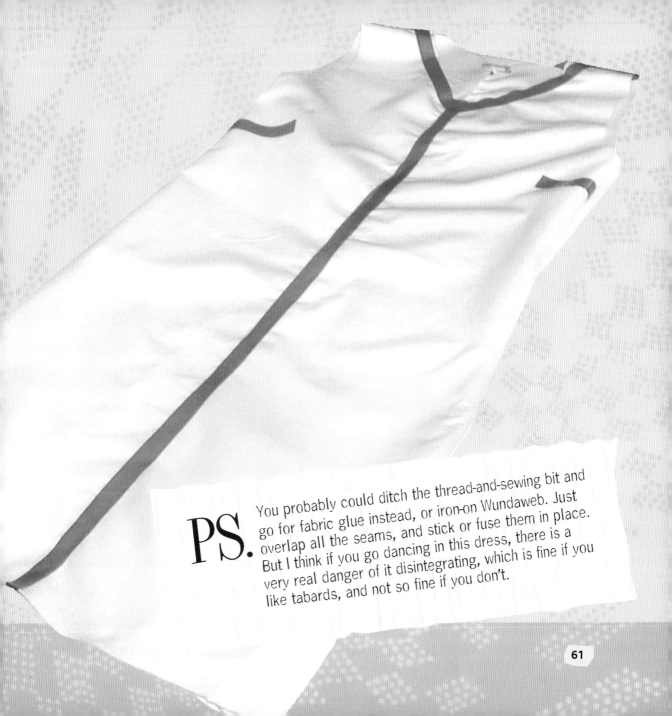

PS. You probably could ditch the thread-and-sewing bit and go for fabric glue instead, or iron-on Wundaweb. Just overlap all the seams, and stick or fuse them in place. But I think if you go dancing in this dress, there is a very real danger of it disintegrating, which is fine if you like tabards, and not so fine if you don't.

Bags in Hand

How to make an easy felt bag, a big beach tote, a drawstring purse, a lovely old lady sewing bag and a clutch

My granny had two handbags: a good leather one for outings and a more scruffy one for every day. In the good one, there was a handkerchief and a rosary; in the everyday one, extra strong mints, a purse, safety pins, spare pairs of glasses...I have two bags times about 20. They are stuffed in cupboards and hanging off doorknobs and generally in a muddle in the bottom of the wardrobe. I've got elegant lady handbags from charity shops that I never use, small, glittery evening bags that I sometimes use and huge totes that I am always lugging around crammed full of things that I don't really need. In fact, I ♥ Mary Poppins-style bags that can easily hold a plant stand, a seventies copy of the Vogue sewing book, a tin of travel sweets, a bundled-up all-weather coat and a small dog. I am not a big fan of brand-new luxe handbags that cost a fortune...for that kind of pirate treasure-chest money, I'd rather go on a few

holidays and spend my doubloons on crazy golf and ice cream and wine. I prefer drawstring bags made out of leftover bits of fabric, clutch bags embellished with sequins and knitting bags swiped from the darkness of the craft cupboard and proudly displayed in the daylight.

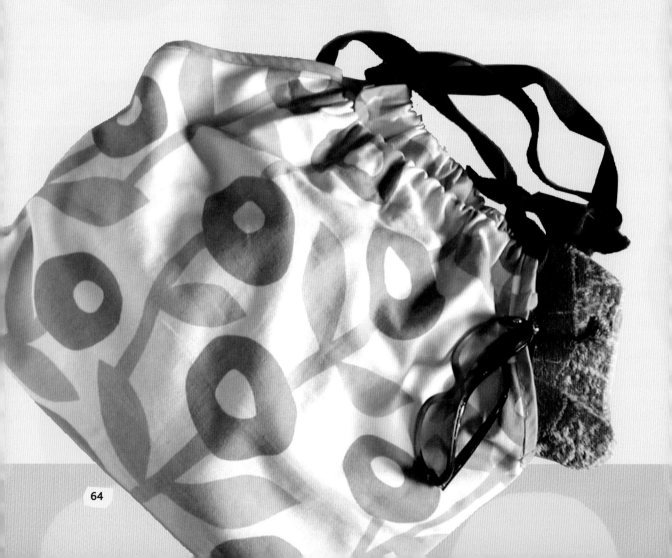

A Felt Bag

The easiest bag in the world to make is a square felt bag with two little handles made out of felt or cotton tape – this is a woven strip of fabric, which comes on a roll and in lots of colours. You can usually buy it by the metre. You could make it as a present for your niece, but with some sequins and appliqué, it is also perfect as an evening bag. And if you make it from very big felt squares, you can shove your chilly-evening cardigan in as well.

(ONE NEEDLE)

- 3 squares of craft felt, whatever size you want your bag to be (Two are for the bag, the remaining one is for the handles.)
- Some stuff to decorate it with

- First, make the handles (or else use cotton tape).
- Cut two strips 6–8cm wide and as long as you think you'd like the handles.
- Fold the strips in half lengthways, and stitch them together all the way around in brightly coloured thread. Because it's lovely un-fraying felt, you don't need to do any zigzagging.
- Have a little think about what you want to put on the bag.

I once saw the most perfect bag. It was in the shape of a horse chestnut in green silk, and nestling inside was a shiny brown silk conker purse. It was the sort of bag that inhabitants of the fairy kingdoms would bring to dances. But it looked like it could only be made by the dexterous elves who helped out the old shoemaker. A vintage Enid Collins bag, on the other hand, looks within the realm of the possible. Customisation was her thing. She covered totes with sequins and rhinestones and

little painted scenes...including signs of the zodiac, glitter bugs and sea gardens. She also really liked owls. Inspired by Enid, I'm keen to make my own vivid scenes. The list so far?

❶ An urban landscape with a jumble of skyscrapers.

❷ A castle bag, complete with castellations and portcullis. And if I were feeling sinister, I might add a few circling vampire bats.

❸ An Art Deco tulip with beads and glittering thread.

❹ A brown branch with a sprig of bright-green spring leaves.

❺ A bird made out of a patchwork of scrappy fabric.

● Do all the decorating before putting the bag together; it's much, much easier that way. Remember to leave enough space for the side seams and the turned-over hem at the top.

● Then, sew the two squares together along the bottom.

● Sew the side seams.

● At the top, turn a hem under – 3cm should do the trick. Sew it.

● Pin the handles on, and then sew them to the inside or the outside of the bag, whichever you like the look of best.

Fabrics other than felt

You can make this bag in pretty much the same way in other fabrics. I've made bags in vinyl picnic-table material, fake suede, fun fur, faux leather, expensive brocade and cheap cotton. And a deckchair bag in red, orange and yellow stripes with handles made out of wooden doweling and big wooden beads. I've got a specially saved bit of upholstery fabric, which is called 'Belle Époque' and has an Art Nouveau look about it, to make into a carpet bag, carpet slippers and carpet coat, as soon as I buy machine needles that can cope with the fabric.

Instead of using two bits of fabric, you can just use one. Fold the fabric in half, right sides together, and have the fold as the bottom of the bag. The bag's shape can be a long oblong or a small rectangle, or anything in between; it doesn't have to be a regular shape at all, but straight lines are easier to sew.

To make the handles for the bag, in much the same way as the felt handles...

▲ Cut out two strips of fabric...long for long handles, short for short.
▲ Zigzag.
▲ Then press a skinny hem all the way around the strips on the wrong side of the fabric.
▲ Fold the strips in half lengthways, wrong sides together, and sew around the edges to finish off the handles.

Putting a pocket on

And if you're going to put a
pocket on the front or in the
inside, do it before you've
sewn the bag up.

- Cut out a rectangle of fabric
 the size you want your pocket
 to be.
- Zigzag the edges.
- Decide which edge is going
 to be the top of the pocket,
 and sew a 1cm hem on this
 but **don't** sew the other
 edges.
- Now sew the pocket to the
 bag but **don't** sew the top.
 Otherwise you will have a
 nice decorative rectangle,
 but you won't be able to
 put anything in.
- To make a divided pocket,
 all you have to do is run a
 line of stitches down the
 front of the rectangle once
 it's been sewn onto the
 bag.

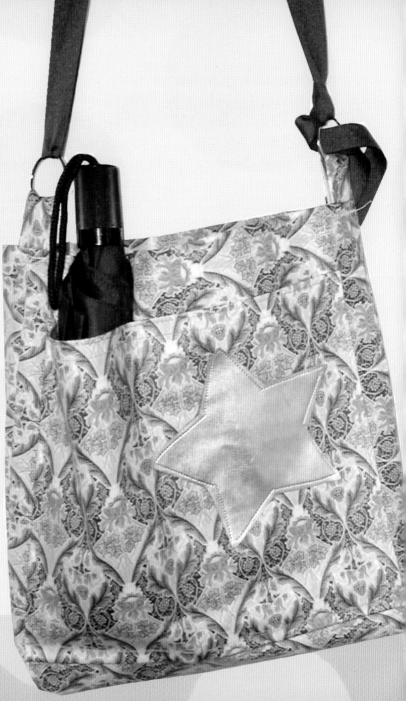

A Slung-on-One-Shoulder Bag

This was my favourite bag for a long time. I put a row of big gold sequins along the top edges, for that disco glitter-ball effect.

♦ Zigzag all the edges, and put a strip of iron-on interfacing along the top of the bag on the wrong side of the fabric; this will stop the top of the bag getting all floppy.

♦ Fold the fabric in half widthways, right sides together.

♦ Press a skinny hem along the two top edges of your bag, for neatness' sake.

♦ Stitch up the side seams. Press.

♦ Sew a 4–5cm hem on the top of the bag, wrong sides together. (You can make this hem bigger if you feel like it.)

♦ Pin and then sew the handles on.

♦ A bit of reinforced stitching is good, especially if you are going to be carting heavy stuff around in it. This basically involves sewing an 'X' shape on both ends of the handles after you've sewn them on. For a bit of extra colour or contrast, hand-stitch a bright ribbon around the inside. It'll also beautifully cover up any cronky stitches.

♦ Add poppers or ribbons to keep the top together.

♦ Pop your fave book in the bag and an apple, and then head to the park to look for herons.

(ONE NEEDLE)

■ About 100cm x 82cm of fabric (You can use more or a lot less, depending on the size you want your bag to be; it doesn't have to be oblong.)

■ 1 strip of iron-on interfacing to reinforce the top of the bag, 100cm x 4cm

■ 2m of wide cotton tape, cut in half, for the handles

■ 1 row of poppers or a piece of ribbon

■ Another 100cm x 82cm of fabric if you're going to line the bag

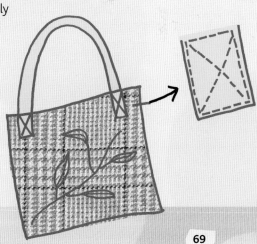

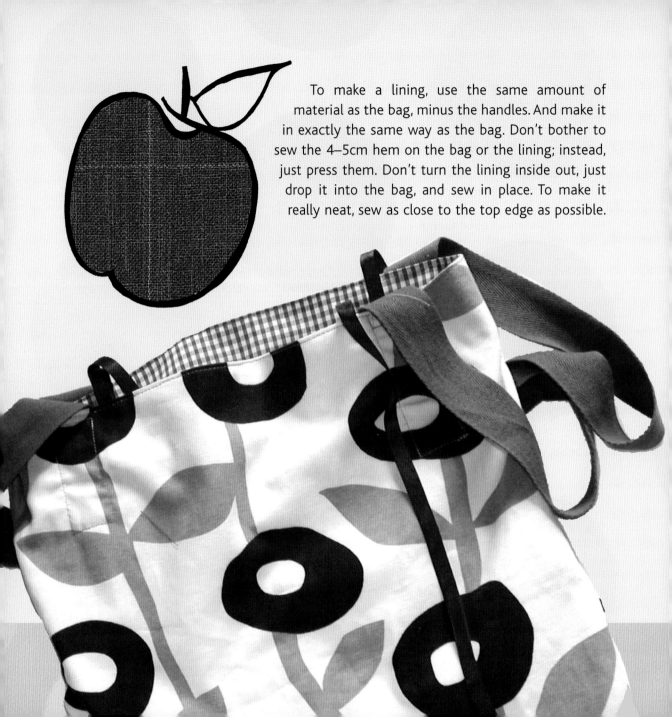

To make a lining, use the same amount of material as the bag, minus the handles. And make it in exactly the same way as the bag. Don't bother to sew the 4–5cm hem on the bag or the lining; instead, just press them. Don't turn the lining inside out, just drop it into the bag, and sew in place. To make it really neat, sew as close to the top edge as possible.

A Huge Beach Tote

Another great bag, which fits loads in. I fill it to capacity with things I don't really need, and then spend the day lugging it around, with one shoulder much lower than the other.

Apply pretty much the same sewing principles as above. But this time, instead of making an oblong, cut out two shapes like this:

- Zigzag the edges of the fabric, and sew up the bottom seam, right sides together. I would put another row of stitches close to the first, just to make it more sturdy.

- Then sew the side seams, right sides together, but STOP about 27cm from the top. Press a little hem along the unsewn side seams, and along the top of the bag. Then to make it look pretty, sew brightly coloured bias binding over all the seams, including the ones inside the bag.

- To make drawstring handles at the top of the bag (which is what I did because I liked the way it pulled all the fabric into pleats), turn under a hem of 6cm, stitch it in place and then thread two long lengths of wide, coloured cotton tape, doubled up, through the hems.

(TWO NEEDLES)

- 1 piece of fabric 100cm x100cm (or whatever dimensions you wish your bag to be)
- 1 card of brightly coloured bias binding
- 1 roll of wide, coloured cotton tape or interfacing

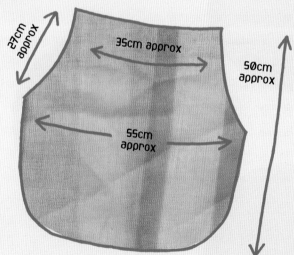

27cm approx

35cm approx

50cm approx

55cm approx

Or for static handles, which are just as easy...

● Put some interfacing along the top of the bag on the wrong side of the fabric before you turn over the hem, then stitch the handles to the wrong side of the bag, turn the hem over, and stitch that in place.

The bags above are flat, but with a small change of shape, you can create a bag with a gusset (which has to be my LEAST favourite word in the world).

TOP TIP You could always line your beach tote with a cut-up patterned towel for extra seaside appeal.

A Bag With a Gusset

■ Fold the fabric in half, right sides together,

(ONE NEEDLE)
■ 1 piece of fabric (whatever size you wish your bag to be)
■ 1 roll of cotton tape or interfacing
■ 1 piece of card

and at the bottom corners, cut out little squares, like this:

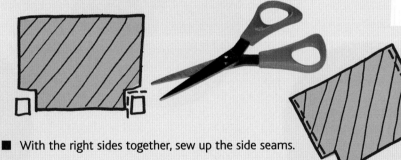

■ With the right sides together, sew up the side seams.

■ Then pinch the corners together, and sew across them diagonally. Drop a piece of card into the bottom before you line the bag, for a bit of extra strength.
■ Add the handles, as for the beach tote, or...

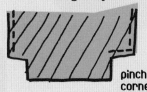

pinch the corner together

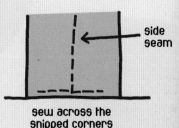

side seam

sew across the snipped corners

Getting a handle on things

Don't restrict yourself to the cotton-tape/fabric handles scenario. Invest in one of those riveting kits (about £6 from haberdashery departments), punch four holes in the bag, and then use two octopus bungee cords (about £1 each) as handles. Or make little fabric loops, add D-rings and some grosgrain ribbon. And for a really sturdy combination, think rivets, carabiners and a bit of climbing rope.

Bags and Baggage

I have always liked those nosy features in newspapers and magazines that reveal the contents of a (usually famous) person's shopping basket, shoe cupboard, bookcase, etc., as clues to the mystery of their personality. Here's what's in my bag:

A nutmeg

Door keys

A school notebook, with squares instead of lines

A lucky stone, black and grey

A thimble, too small for any of my fingers

A phone

Cards

A pencil with a purple eraser on the top

Stamps

A red lipstick

A raggedy silver cardigan

A bit of scrunched-up fabric

The greeny-blue tape measure from the Christmas cracker

A copy of M. F. K. Fisher's With Bold Knife and Fork

Cloves

A wonky umbrella

An orange

Nothing very mysterious there. Except for the nutmeg, maybe?

Sometimes you have to abandon the huge tote for something more compact and elegant, and a drawstring bag is the perfect place to keep together all those little items that are forever migrating to the corners of more hefty baggage.

A Drawstring Bag

- Cut out your oblong of fabric – a scavenged bit of old-fashioned curtain material will look pretty and retro; a small piece of sleek satin will make a bijou evening bag.
- Zigzag all the edges.
- Press a skinny hem all the way around the oblong but don't sew it.
- Fold the fabric in half widthways, right sides together, and then stitch one of the long side seams all the way to the top together; a 1cm seam should be fine.
- On the second side seam, stop about 6cm from the top. On both sides of the split, turn a 1cm hem under.
- Next, fold the top edge over, and make a 3cm seam.
- Get some pretty ribbon, some rough-and-ready twine or some bright knitted cord, attach a safety pin to one end, and thread it all the way through the seam. Knot the ends together. Make a little brooch to decorate the front. Then let it dangle beautifully from your wrist or belt.

(TWO NEEDLES)
- About 27cm x 45cm of fabric
- 1m of ribbon, twine or cord
- 1 safety pin
- 1 little brooch

You can make a drawstring that pulls from both sides by leaving the top 6cm of both side seams unsewn, and then going ahead with the turned-over-at-the-top hem as before.

Or for a lower-down drawstring, you can turn over a bigger hem at the top of the bag, and then do a second row of stitching about a centimetre away

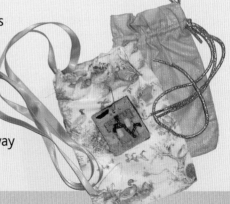

from the first. Get a sparkly shoelace and thread that through the hem instead of a ribbon through the two rows of stitches. Pop in your lipstick and a tiny bottle of scent, and you're ready to go.

Bigger Bags with Drawstrings

I pretty much walk everywhere, so there's always a scene of me around the corner from a party, leaning against a wall and scuffling my everyday shoes into a plastic bag, and fishing my party shoes out of another carrier bag, by now bashed about by my umbrella and book. The answer to this scuffling/storage dilemma is a shoe bag. If you buy very expensive shoes, not only do you get a lovely box, you also get a lovely drawstring bag to keep them pristine. In fact, if you buy Chanel *chaussures*, you get a bag for *each* shoe. So even if your glittery Mary Janes are cheap chic, you can add your own touch of luxe with a handmade shoe bag. Use thick cotton, fleece or velveteen...or any fabric that you like the look of, as long as it will survive a bit of wear and tear in your bag. Use the pattern for the regular drawstring bag opposite, just make it in a bigger size. And if you want to add a really personal touch, chain-stitch your name to the front in glittery thread before you sew the bag up. Or appliqué on some cheery felt cherries. And you could make a giant version and use it as a laundry bag.

A Clutch Bag

Another dead simple bag to make is a clutch. This is the sort of bag a nightclub chanteuse might have tucked under her arm as she made her way to the microphone to sing smoky songs about lost love to men with slicked-back hair. The bag would match the brocade of her evening coat. I see her pause to drink a Manhattan and re-applying her fire-engine-red lipstick with a compact neatly stowed in her clutch. Even if you hate Manhattans and don't own a brocade evening coat, you can still clutch a clutch.

(TWO NEEDLES)

- 25cm x 32cm of glitzy fabric, for the outside of the bag
- Another 25cm x 32cm of lush satin, for the lining
- Another 25cm x 32cm of stiff iron-on interfacing
- 2 medium buttons or 1 large one
- 1 twist of very thin cord

- Zigzag the edges of both bits of fabric. Iron the interfacing to the wrong side of the fancy fabric.
- Press a 1cm hem onto the wrong side of both ends of the fancy fabric.
- The clutch bag is just like an envelope, so there's going to be a flap. Get out the measuring tape, and put a pin in 21cm along both of the long edges.
- Fold the fabric, right sides together, so that the bottom edge meets the pins.
- Sew the sides up to the pins, right sides together.
- Turn the bag the right way out.
- On the flap, press under a hem on the sides, so that it's streamlined with the bag bit.
- Work out where the button is going to go on the front of the main bit of the bag, and sew it on now. If you're using two buttons, sew them on.

- Get the lining, and do exactly the same as above, except for the button bit.
- Drop the lining into the fancy fabric pocket. Your instinct will tell you to turn it inside out. Don't.
- As close to the edge as possible, sew the lining to the fancy fabric along the sides and top of the flap.
- And then along the top edge of the pocket.
- Stitch the cord into a loop on the flap to match the button on the bag.
- Load up on lipstick, and tuck the clutch under your arm.

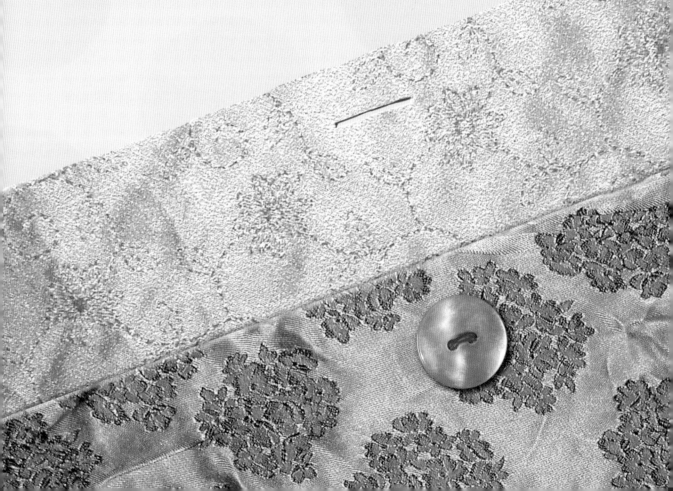

A Lovely Old Lady Bag

Recently, at a jumble sale, I bought an old lady sewing bag. Made out of fifties curtain material in peacock blue and pink and emerald green, it was meant to be a handy place to store all my knitting needles. But I liked it so much I couldn't bear to leave it at home, so it's become my day bag. It's a good size because you can fit just enough stuff in, but not too much. The old lady knitting bag has enough room for a book, a couple of balls of wool, a bus pass and some make-up. And maybe an umbrella to combat showers. That's it. I liked it so much that I had to make a spare.

(TWO NEEDLES)

- 42cm x 66cm of fabric
- 2 plastic handles (mine were from a craft superstore in Balham and cost about £3. I've seen wooden ones in John Lewis, but they start at about £8 and head upwards towards the £20 mark), shaped like this:

You don't have to stick to these dimensions; you could make the bag a good deal bigger, and add a GUSSET too.

- Zigzag the edges.
- Fold the fabric in half widthways.
- With right sides together, sew the side seams, stopping about 13cm from the top.
- Turn a skinny hem under on the tops of the fabric.
- Now sew a 1cm hem on all four sides of the two sets of splits.
- Get the two handles, and feed the fabric through, until there's about a 3cm chunk of cloth on the inside of the bag.
- Sew in place with a neat row of hand stitches, or whiz along on the machine. Take care not to sew over the handle; if you do, the needle will snap in half.

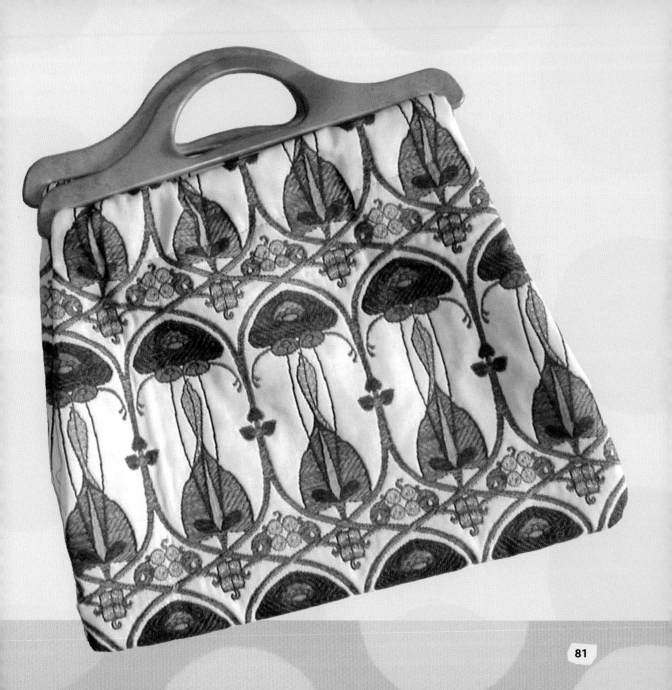

Skirting the Issue

How to make a few skirts to run for the bus in and one that you can't

One of the nicest things to do before embarking on any actual sewing is to spend a fair bit of time with your chosen bit of fabric draped around you in an interesting way. Ideally, you should spend a good few minutes walking up and down in front of the mirror, with a length of midnight-blue liquid satin swathed across your middle, a strip of furnishing fabric as a belt, a safety pin holding the whole thing together and wearing a selection of shoes. The shoes aren't in any way necessary to the sewing project, but there is something really fun about sashaying around in high shoes and a bustle of material. And you almost instantly realise that there is your skirt, pretty much all that's lacking is the thread and a few stitches to make it official.

Remember making a skirt for Sindy with a bit of old ribbon and an embroidered hanky when you were six? You can apply the same simple ingredients: **one small, thin, starchy bit of fabric + one long, floaty bit of cloth + a brooch = a wraparound skirt for the grown-up you. It's a little haphazard, but in a good way.**

An Easy Sindy Skirt

- Wrap a tape measure from hip to hip, around your back, then back around both of your hipbones. Make a note of that measurement, and then cut out a strip of stiff fabric to match that magic number (the strip can be as thin or as thick as you like), so if you measure 128cm all the way around, add 2cm if you are thinking of hemming it.

(ONE NEEDLE)

- ■ 10cm x 150cm of stiff fabric – a bit of upholstery fabric would be good, as would some thick cotton, linen or velvet
- ■ 150cm x 150cm of floaty fabric, like thin cotton, satin or silk
- ■ 1 brooch or big safety pin

- Zigzag all the edges, and turn a 1cm hem all around if you can be bothered.

- Cut another piece of the floatier material to the same magic number; this is the top skirt bit. Make it much wider than 10cm, unless you want your knickers to show.

- Zigzag all the edges, except for the hem.

- Sew this floaty piece of material to the stiff bit of material.

- Finish off the hem.

- Wrap the skirt around you, and fasten with a big brooch or a MASSIVE safety pin decorated with tiny wooden beads or big woollen pompoms.

You could make this with a thicker fabric for a more structured look, if fine and floaty really isn't your thing.

TOP TIP Mostly, it's a good plan to leave the hem until last. Make your skirt (or dress) longer than you think you'll need. Finish off everything else, and then decide on the skirt length. Before you start chopping away at the excess fabric, remember to leave enough to actually make the hem.

Back to draping. Draping is a good idea because it'll get you inspired, but it's also a good way to see how the fabric falls with a person under it. It's especially good if you have acquired a gorgeous length of fabric with no fixed intentions for it. Just flouncing for a bit can give you all sorts of good ideas, the way the fabric folds can make you think of pleats, or a mini, or a retro A-line, or something far more seductive. I love these lines of seventeenth-century verse from 'Upon Julia's Clothes' by Robert Herrick:

Whenas in silk my Julia goes
Then, then methinks, how sweetly flows
The liquefaction of her clothes.

It would be brilliant to make a dress or a skirt just like that.

It can dispel a few notions too. Like the idea that you could make a skirt from the material used to line greengrocers' shelves. Fake grass scratches your legs and is not comfortable to sit on. That said, skirts can be made of anything. Designer Hussein Chalayan made skirts that shattered when they were tapped with a hammer, and other skirts that telescope into round wooden tables. A friend of mine wore a cleaning lady's outfit to a fancy-dress party. She'd made her skirt from blue J-cloths and her corsage from a chamois. It looked nice, and had many practical advantages when drinks were spilt.

Most fabric can be turned into a skirt with ease. Some skirts are so easy to make, in fact, that you can head to the shops in the morning, buy a metre and a half of fabric, a bit of ribbon or cord (and maybe a fairy cake with inspirational icing and decorations – little candied flowers, hundreds and thousands), then return home, and be wearing the new drawstring skirt in **a couple of hours**. It won't be the sleekest of skirts, but it'll be nice and slouchy and **VERY, VERY** easy to make! **EASY!** Which brings me to the vexed question of elastic. A skirt with an elastic waistband is just as easy to make, but the very idea of it makes me trembly about my future. Yes, you can make it in a couple of hours, and it will look enticing draped across a chair. But once you put it on, chances are you'll probably look like a heffalump.

There are exceptions to this rule. I met my friend Rachel for a drink and she was wearing the most beautiful red silk vintage gathered skirt, with little printed postcards scattered around the edges. And there was no button or zip, or hooks and eyes, or poppers. Nope, the waistband was a series of narrow elastic strips, and it looked lovely.

I was immediately converted, and went home and made two skirts with gathered waists, one in Gretchen gingham, with a patchwork pincushion as a decoration and some lovely retro seventies ribbon along the hem. The other was constructed from a requisitioned fifties skirt. The pattern is of rust and cream and mocha-brown scribbled roses, and the original was made of acres of material. And when I put on my elasticated version, I looked like I was made up of acres too. It looked pretty if you couldn't see the waistband, but when you could, you saw a not very appealing bunched-up-middle look and a wide-as-a-caravan rear-view look.

And it *is* tempting to ignore all these things. Making an elasticated skirt involves not much sewing. It is just basically a tube of material, with one side seam and a folded-over waistband with a piece of elastic threaded through it, which gathers the material, but I'd be tempted to NOT make this skirt for myself, but make it for a little girl instead. They might not look genius on you, but these skirts look really lovely on children. Run them up in bright, cheeky colours, cute cartoon prints or dainty florals and they'll make perfectly stylish presents for any small girl of your acquaintance. And it'll take no time at all.

And because it is such a simple shape and so speedy to make, you can let your imagination run riot. Make a grey felt cat, with glittery whiskers, and sew it to the front of the skirt, add gaudy braid or huge pockets in a clashing fabric. All those cutie details and ideas that you like, but feel a little too grown up to apply to your own outfits, can be happily sewn onto a child's skirt.

A Pretty, Small Elasticated Skirt for a Tiny Girl

(TWO NEEDLES)

- 74cm x 30cm of fabric, if the child is tiny, more if they are bigger (the more fabric you use, the more gathered the skirt is going to be)
- 1 card of 1cm-wide elastic
- 2 safety pins

- Zigzag all the edges.
- Fold the fabric in half widthways, right sides together.
- Sew a 1cm side seam. Press.
- Turn a 1cm hem under the top edge of the skirt. Press.
- Pin a further 2cm hem under on the waistband, apart from a 3cm gap at the centre back. This is where the elastic is going to be threaded through. Once you're happy that the waistband is nice and straight, sew it, remembering to leave the gap for the elastic at the bottom edge of the hem. Press.
- Wrap the elastic around the child's waist. Make sure it feels comfortable, and then add an extra 2cm. Once the elastic is in place, that's it; it'll give a bit as they move around, but don't make it too tight or too loose because, unlike the drawstring, it's not adjustable.
- Attach a safety pin to each end of the elastic.
- Fasten one safety pin to the fabric to stop the whole of the elastic disappearing as you thread the elastic through the casing. Use the other safety pin to pull the elastic through the casing.

- Even out the gathers as you go. When the two ends of the elastic meet, pull each end out of the opening, and overlap. Stitch in place nice and securely.
- Let the elastic ping back into place. And finish up by stitching up the last few centimetres of waistband.

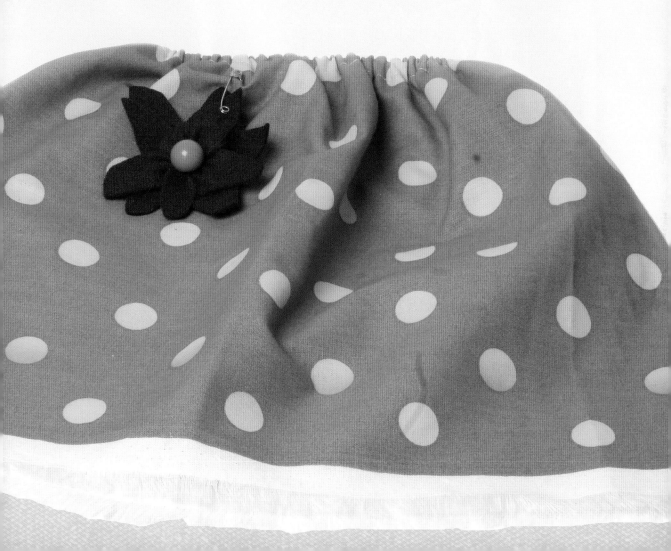

The Don't-Say-I-Didn't-Warn-You Elasticated Skirt for You

For a gathered version:

✳ Repeat all the stages described in the above instructions for *A Pretty, Small Elasticated Skirt for a Tiny Girl* folding widthways.

(TWO NEEDLES)
- 120cm x 60cm of fabric
- 100cm of 1cm-wide elastic
- 2 safety pins

For a non-gathered version:

There is another way to take advantage of the ease of elastic, and that is to make a skirt without the gathers. Use a lot less material, and cut out two pieces of fabric instead of one. When it comes to sewing it together, you'll have two side seams, but you pretty much follow all the steps above. You could make it straight or have it flared at the hem, but gradually taper it as it goes towards the waist. That way you can have a swishy skirt, still with an elasticated waist, but with less bulk. Or make it more frugally in an A-line shape. And if you're still not convinced about the elastic, use a drawstring instead.

A Fairly Gathered Drawstring Skirt

If you made any of the drawstrings bags in the previous chapter...well, it's just as easy to make a drawstring skirt in exactly the same way, just with more material. Remember to leave the bottom of the tube undone though, otherwise you will have created an outfit designed for a sack race. A skirt with a drawstring waist is perfect for a day at the beach. Whiz one up in a sturdy piece of 100% cotton, in a summery pattern, and then make a seaside paraphernalia bag to match. Or use thinner, filmy cotton for a more romantic beachcomber look. And you could make beachcomber accessories too: a seashell necklace, a seaweed belt, a pirate eye patch and a pearl necklace.

(TWO NEEDLES)
- 120cm x 60cm of fabric
- 1 safety pin
- 200cm of grosgrain ribbon or cotton tape (2cm wide if you're using sturdy fabric)

- Zigzag all the edges.
- There is only one side seam to this skirt, so fold the fabric in half widthways, right sides together, and sew a 1cm seam up the side, stopping 6cm from the top. You should now have a very wide tube of material. Don't worry, it'll be all right.

- At the top of the skirt, on each side of the 6cm gap, turn over a 1cm hem, press, and sew.
- Now for the waistband. Turn over a 1cm hem, and press. Then turn a further 2cm over, and sew along the lower edge of the hem.
- Attach the safety pin to the end of the grosgrain ribbon. Pull the safety pin and the ribbon through the casing. Even out the ribbon and the gathers.
- Press a 1cm hem along the bottom of the skirt, and sew it.

Or...

- If you're feeling very Pristine Christine, turn a 1cm hem under, and press.
- Then turn another 1cm under, press, and then sew.
- Slip on the skirt, and tie the ribbons at the side in a big bow, with two nice strands furling down the side.

For a more gathered look, add more fabric to that 120cm. For a longer skirt, add to that 60cm. If you are using fine cotton, you can use a thinner ribbon or cord, and a more slender casing for the waistband – reduce the 2.5cm to maybe 1.5cm.

Not too sure about the flouncy nature of the big bow? Use a shorter piece of ribbon.

To make the skirt for a small girl, cut down radically on the amount of fabric and ribbon, but make it in the same way.

Now find your flip-flops and bucket and spade, and buy a cheap day return to the nearest seaside destination.

Elizabeth's Wraparound Skirt

My friend Elizabeth has a fondness for clothes that are made from regular shapes...squares and rectangles are transformed into tops and skirts. Her version of the wraparound skirt is so cool and simple – and easy to make and wear – that it's tempting to make a version for every day of the week. It's constructed from a rectangle of cloth (it works best with a stiffish fabric), with one of the selvedge edges used as the bottom of the skirt, so there's no need to turn up a hem. And it's fastened by Velcro. The only shaping is a gentle concave

(TWO NEEDLES)
- 150cm x 150cm of fabric
- 150cm x 150cm of lining
- 1 hook and eye
- 1 piece of Velcro (about 15cm) or 2 bits of ribbon (each about 30cm long)
- 1 roll of iron-on interfacing (if you want a more angular shape)

scoop cut at the back of the waist, so that the skirt sits prettily, rather than gaping. If you're not fond of Velcro, use buttons instead. Although Elizabeth's skirt is made in one piece, you can ring the changes...add a strip of brightly coloured fabric to the end of the rectangle, or cut out a longer length of fabric, and pleat a chunk at one end for an abbreviated kilt.

For some reason, these seem to be the longest instructions in the book, but don't let that put you off – the instructions may be long, but the skirt only takes a few hours from start to finish, a little longer if you add in a sumptuous ruffle.

- This skirt is designed to nestle just above your hipbones, so place one end of the tape measure on your right hipbone, pull the tape across your stomach, around your back and across your stomach again to your left hipbone, and make a note of that measurement. For a fairly fitted look, make sure the tape is pulled snugly, but if you like to hang loose, allow a little slack. Snug or slack, add an extra 2cm to the measurement.

- Next, dangle the tape measure from your waist towards the floor to work out how long you want the skirt. Because you're going to be using the selvedge as the hem, if you need to make the skirt shorter, trim away any extra on the waist edge! And then add an extra 1cm to the length.

- Spread your nicely ironed fabric out on a flat surface, wrong side up, and chalk out those measurements. Use a ruler to get the length right, and the waist edge nice and straight, and then cut it out.

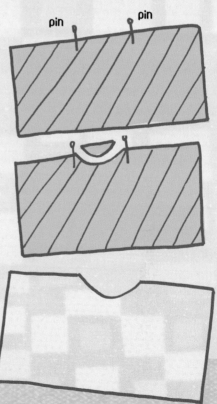

pin pin

- Wrap the rectangle around your hips, and have a quick look in the mirror. At the back of the waist, the material will gape a little, put a couple of pins in to mark each end of this gap.

- Cut a shallow concave scoop between those two pins, so that the skirt will fit neatly.

- Turn the fabric up the right way. Pin the lining to the right side of the fabric, starting with the hem, with the lining selvedge 1cm up from the fabric's selvedge. Carefully pin the lining all the way around the fabric, making sure there are no wrinkles or crinkles.

- Flip the fabric over, so that the lining is on the bottom, and then cut around the lining, using the skirt as a template.

- If you're feeling confident, sew the lining to the fabric, 1cm in from the edge. A bit wobbly? Tack the lining to the fabric before heading to the sewing machine.

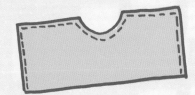

- DON'T sew the selvedge edges!

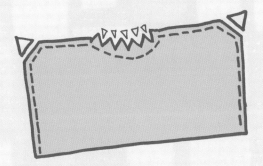

- Snip out a triangle of fabric at the top corners of the rectangle on the inside of the skirt, in the seam allowance. Cut through the skirt fabric and the lining too. Take care not to snip into your stitches.
- Cut a series of little triangles in the scoop too, again taking care not to snip into your stitches.

- Press all the seams.
- Turn the skirt the right way out, and press again, so that the lining is nice and flat.
- Wrap the skirt around your middle, so that it fits the way you want it to. Place a pin where you want the hook to go, over your right hipbone, on the lining side.
- Hand-sew the hook in place. Sew the eye to the right-hand edge of the waist. Do up the hook and eye.
- If you are using Velcro (there's even a no-sew version, just peel back the plastic paper, and stick in place, but make sure you know where it's going – once it's stuck, it really is stuck), it's going to go on the inside of the right-hand side, along the top edge. Match up the second piece of Velcro on the outside of the left-hand side.

Ribbon ties will give the skirt a looser feel. Sew one strand to the corner edge of the right-hand side of the skirt. Sew the second strand about 5cm down the left-hand side. Tie the two strands together in a double bow to keep the skirt in place at a nice slanted angle.

If Velcro makes you think of some of the worst moments of Bucks Fizz in Eurovision, ditch it, and replace it with a big button and a button loop, made from a small bit of ribbon or bias binding.

To add structure and angularity, iron a strip of interfacing to the inside of the skirt, under the lining, along the waistband. The piece should go all the way around the waistband of the skirt, up to 15cm in length.

TOP TIP If you're using plain fabric, with no print or pattern, a little bit of appliqué in a contrasting colour can look very striking. Appliqué? This just involves cutting out shapes, maybe flowers, maybe monsters, from nice bits of material and sewing them onto your skirt. Any decorative feature should be sewn onto the top of the fabric before the lining is in place. That way you get a nice flat surface to work on, and the lining doesn't get all bunched up from too many stitches. Try a length of ribbon zigzagged in place, felt flowers, a line of beautiful braiding or a hundreds-and-thousands sprinkle of sequins. Or what about a few rows of ric rac? It's cheap, comes in loads of colours, and looks just like a child's drawing of the sea; so you can have the ripple of waves lapping across the width of your skirt. And ruffles can be lovely too…

Ruffles

I'm very fond of ruffles, from a sweet choirboy frill to a medieval face-framing ruff to the louche flounce of a cuff on a sleeve. They also look good adorning the neck of a wraparound top or dress and around the hem of un-fussy dresses. For a full-on flounce, you'll need a strip of fabric three times the length of the edge you're going to sew it on; for a more restrained ruffle, twice the length of the edge will be just fine. The selvedge could be used as one edge (no-sew short cut!), but zigzag the other edge to keep it neat and tidy. For a more time-ravaged ruffle, zigzag a little away from the edge, and let the threads fray. If fraying isn't your thing, stitch a little hem all the way around the strip of fabric. I like doing the next bit by hand, but feel free to use the sewing machine. Leave a long, loose thread at the beginning of the fabric strip, and sew a row of running stitches along one edge of the whole length of the fabric. Do another row of running stitches about half a centimetre down from the first row, again leaving a long, loose thread at the beginning. Gently bunch the fabric along the thread until it's nice and evenly gathered, then machine-stitch the gathers in place. Or you can sew the line of running stitches down the centre of the strip of fabric. Sew the ruffle to anything that looks in need of a bit of flounce.

I love making lists of all the skirts I'd like to have. Sometimes just thinking about making something is as good as actually getting out the sewing machine and getting to work. Top of my friend Rachel's list is an autumn bonfire skirt, decorated with flames or fireworks, with a belt made from matches. I'm quite fond of the idea of shimmery leaves crinkled over rust wool. For spring you could make it in blue shower-proof material, and add on little beads that look like raindrops.

A Dreamy Skirt Wish List

One day I'll get round to making:

1 A silver skirt perfect for a girl astronaut.

2 A skirt in dark velvet decorated with small buttons in homage to pearly kings and queens.

3 A silhouette skirt made up in two layers and two colours with an intricate picture cut out of the top skirt. I would like it to look like one of Matisse's cutest. Or the lovely outline I saw of Jean Forbes-Robertson as Peter Pan and his shadow in a National Portrait Gallery exhibition. It was fashioned by Hubert Leslie, who spent a lot of time on Brighton Pier in the 1920s cutting out the silhouettes of passers-by and pasting them into big scrapbooks. His look very elegant. Mine won't.

4 A very plain skirt with a belt inspired by those chains of hand-holding paper dolls. Each doll would be wearing a different outfit.

5 A skirt with a heart-shaped pocket to keep love letters in.

6 A skirt decorated with a huge beaded cobweb with a spider from the party shop nestling at the glittering centre.

7 A skirt festooned with roses made from ribbons.

8 A skirt with rows and rows of different coloured embroidery thread stitched across it with patch pockets and the words 'blue' and 'sky' sewn onto each pocket.

Appetite whetted?

Why not try a more sophisticated version of Sindy's skirt? You make it with three panels of fabric and add a little shaping. This involves putting in darts. Don't be all of a tremble, they're easy.

Darts

Darts are used to give shape to the fabric where it settles at the curvy bits of the body...mainly on the bust, waist and hips (see little pic). When you're making something with darts, these are the first thing you sew; when they are in place, you can get on with stitching the shoulder seams and the side seams, or putting in the zip.

A dart is a tapering seam, stitched into a point, in a nice triangular shape (see, all that geometry did eventually come in useful). There is probably a couture way to sew darts, but I don't know it, so here's how I do it:

- On the wrong side of the fabric, mark out where the dart should go with some tailor's chalk.
- Fold the marked-out dart in half, right sides together.
- Then you could tack it in place, but I usually go straight to the sewing bit.
- You can a) start at the fullest bit of the dart, with a few back stitches, and sew slowly to the point. A few more back stitches will keep the dart from coming undone; or b) reverse...start at the point, end up at the fullest bit.
- Press the darts. In general, vertical darts (e.g. bust darts) are pressed downwards, and horizontal darts (e.g. darts at the waist of a skirt) are pressed towards the middle of your lovely garment.

Taken all that on board?

How about a little darts practice?

A Sophisticated Sindy Skirt

You can make a pattern for this first, before embarking on any actual fabric cutting, out of newspaper, or you can have a go at drawing it straight onto the wrong side of the fabric with tailor's chalk and a ruler.

These are your two pattern pieces. As this is made out of three panels, you will be cutting out one back bit and two front bits.

(TWO NEEDLES)
- 150cm x 170cm of fabric
- 110cm of broad grosgrain ribbon
- 1 hook and eye
- 1 button or a couple of bits of ribbon to keep the skirt in place

■ Fold the fabric, and mark it up like this:

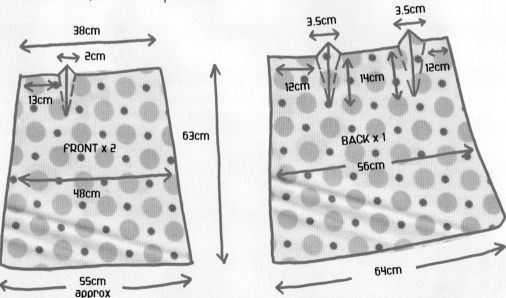

FRONT x 2

38cm
2cm
13cm
63cm
48cm
55cm approx

BACK x 1

3.5cm
3.5cm
12cm
14cm
12cm
56cm
64cm

- Cut out the skirt shapes.
- Zigzag them.
- Sew the darts on the front and back first, and then press them towards the centre.
- Sew the back to the front, right sides together, at the sides. Press those seams, lady.
- Sew a little 1cm hem on the front edges of the skirt. Press.
- Sew a row of stitches all the way around the waist of the skirt about 1cm in from the edge.

- Make a little grosgrain-and-skirt sandwich. Fold the ribbon over the top edge of the skirt, and sew it as close to the bottom of the ribbon as you can. Press.

- Do the hem.
- Sew in that hook and eye.
- Put your ribbons, or a button and a loop, at the corner of the skirt and at the waist, so that they do up nicely.

A Rough-and-Ready Pleated Skirt

⏪ Zigzag all the edges except for the hem bit.

⏪ Lay the fabric out on the floor, and start pleating it like this (see picture). Put in pins to stop the pleats undoing. Start about 6cm in from the edge, and finish up about 6cm from the far edge. Don't bother trying to keep the pleats in ordered rows.

⏪ Wrap the skirt around you. You might have to play around with the pleats for a bit to get the waist of the skirt into proportion. Happy?

⏪ Sew the pleats by running a few of rows of stitching along the top edge of the skirt. This will make the pleats puff out a bit. If you'd like them to lie a bit flatter, sew *down* one side of the pleat for a few centimetres.

⏪ Sew up the back seam – 4cm wide, right sides together. Stop about 20cm from the top of the skirt. (It doesn't have to be a back seam; it works just as well with a side seam too.)

⏪ Turn the skirt the right way out.

⏪ Now turn your attention to that 20cm opening.

⏪ On one side of the opening, turn under a 2cm hem, and press.

⏪ On the other side of the opening, turn under a 4cm hem, and press. You should now have a nice overlap. If you're happy, sew them.

(TWO NEEDLES)

■ 1 piece of fabric, about 3 times the width of your hips, plus about 5cm

■ 3 metal poppers

■ 1 length of grosgrain or Petersham ribbon, about the measurement of your waist, plus a bit more (optional)

- ◄◄ Sew a row of poppers along that bottom 2cm, and sew the popper tops on the underside of the 4cm, so that they match up.
- ◄◄ Get busy with the hem.
- ◄◄ If you feel like it, add a strip of grosgrain ribbon to the inside or the outside of the waist. Outside? It'll hide the stitches and give a bit of oomph to the waist. Inside? Your fine sewing will be on display, plus you'll get the benefit of extra strength too.

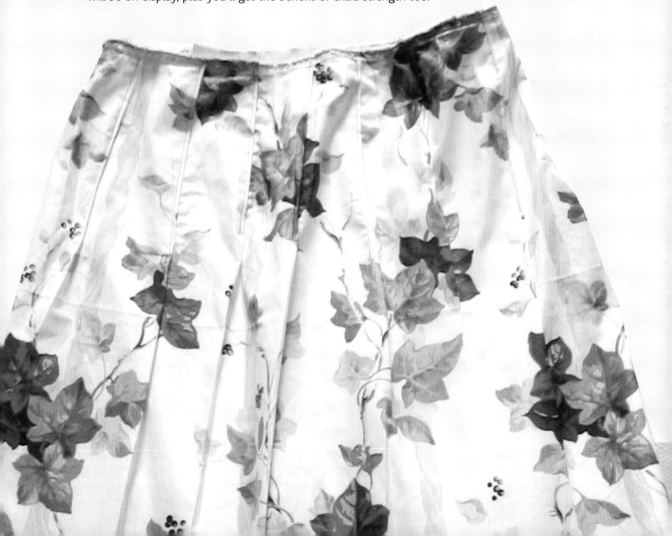

Zip Up, Lady...
How to Fit the Essential Fastener

Tempting though it is to make skirts and dresses inspired by tents and big-top marquees, there will come a time when you want something a little more fitted. Here's where the zip comes in. But **before you start delving into this little section, have a glance at the zip in your favourite skirt or dress**. Reading the instructions for this kind of thing can be daunting, but actually putting all this info into practice is much easier. It's a two-needle project. So, quick peruse of the skirt, deep breath, and off you go.

There are lots of ways to fit a zip, but you only really need to know one. Here it is:

TOP TIP Instead of leaving a 2cm gap and doing the hook-and-eye thing, I quite often sew the top of the zip's pull as close to the top edge of the fabric as possible. Then I just fold over the fabric bits of the zip, and stitch them so they're not getting in the way.

Introducing the Centred Zip...
for Dresses and Skirts

Check the pattern and see what the recommended zip length is. In general, zips in dresses are about 55cm long, and in skirts 18cm.

* Zigzag all raw edges.
* Stitch the seam, right sides together, where the zip is going to go, but leave an opening the length of the zip, plus 2cm.
* Still with the right sides together, **tack** the rest of the seam together, following on from your machine-stitched seam.
* Press the whole seam open, from the top to the bottom.
* Place the zip face down on the wrong side of the fabric, on the tacked bit of the seam, with the start of the zip's teeth 2cm down from the top edge of the fabric.
* Pin the zip in, making sure that the zip's teeth are in the very centre of the tacked seam.
* If you're happy with all of that, tack around the zip – down the sides and across the base of the zip – and then whip out the pins.
* Now turn your lovely garment the right way out.
* OK. Sew the zip in, using the tacking stitches as guidelines...try not to sew over them because you're going to be undoing them in a minute.
* Remove all the tacking stitches.
* Zip up. And down.
* Finish the rest of the garment you're sewing, and at the very end sew a hook and eye to stop any unsightly gaping just above the zip.

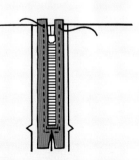

Zips Aren't the Only Way to Achieve Closure

The Hollywood starlet's favourite couturier Zac Posen showed a curvaceous dress at the V&A museum. Fitted as tight as an Edwardian day dress and made from soft-as-a-whisper leather, the floor-sweeping gown was fastened with row after row of hooks and eyes...the sort of fastener that might appeal to a very sexy suffragette. Other ways include:

❀ A row of buttons always looks good, as do metal poppers.

❀ Feeling military? Frogging is the way forward.

❀ If you forego buttons on a jacket or coat, a ribbon tie in a contrasting or matching colour will pull your outfit together in more ways than one.

❀ A drawstring skirt couldn't be easier.

❀ And the same goes for a wraparound skirt.

❀ And you can't beat a bit of Velcro.

❀ Or a safety pin.

My Favourite A-Line Skirt

Drawstring and elastic skirts have a floaty summertime feel about them; light cotton or silk or liquid-look satin printed with apples or sprinkled with flowers are ideal in this style. And wraparound skirts are brilliant in thin wool and stiff, metallic, man-made fibres. But thicker cottons with bolder patterns and winter wool in rich berry colours need a skirt with a little bit of structure and a zip. That's why I love an A-line skirt.

I love the shape of this skirt, a triangle with a flattened top. It is a bit like a blank canvas. You can, of course, make it in a delicious fabric, and it will look brilliant. But then there's ruffles, and beads, and stencils. Plus pockets, scalloped edges, big appliquéd tulips. And then there are seasonal themes. And you can ditch the darts for a skirt that just hangs off your hips in a devil-may-care way.

(TWO NEEDLES)
- 150cm x 70cm of fabric
- 1 x 18cm zip

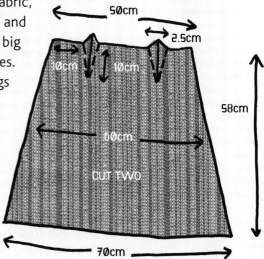

- ✦ Fold the fabric in half widthways, right sides together. Here's the shape you'll need:
- ✦ Sketch this shape straight onto the wrong side of the fabric with tailor's chalk. Or if you think you'll make the skirt more than once (and you probably will), make a pattern first out of newspaper. Cut it out, so you'll have two matching pieces.
- ✦ Zigzag everything in sight, apart from the hem.

- ✦ Do the darts.
- ✦ Put a zip in one of the sides.
- ✦ Sew up the other side seam, right sides together.
- ✦ Press a skinny hem around the waist of the skirt.
- ✦ Press a further 1cm under at the waist, and then sew it.
- ✦ Now quickly do the hem.

Make a huge pot of tea, and eat the fairy cake with inspirational icing. You have just created one of the best skirts in the world. HURRAY. Now get a pen and paper and write a list of all the skirts you'd like to make. Think of ways to embellish them as you sip. Pockets. Ribbons. Spray paint. Melted crayon...

Soubrettes with a desire for a flirty swirl of a skirt can just cut out bigger triangles. But make sure you taper the fabric towards the waist. You'll need more material and a firm hand in windy weather. Take a tip from Queen Maud of Norway who wore a flared skirt for cycling in the early 1900s (she eschewed the latest look – bloomers). It had little pockets sewn along the hem, which she filled with lead shot to stop the skirt blowing up over her royal head on blustery days.

A Screen Heroine's Skirt

Usually, I like a skirt you can run for a bus in, but after watching Shirley MacLaine slink across the screen as Irma La Douce in black satin, I began to think that there *were* occasions when a skirt as straight and narrow as the path to righteousness was definitely desirable. Irma's skirt has a wicked side split, and satin can be a very unforgiving fabric if it's too clingy, but with just the right amount of tightness, it can be very sexy. Add in Irma's emerald-green sleeveless blouse and you will win awards for statement dressing. But not for sprinting for the 137.

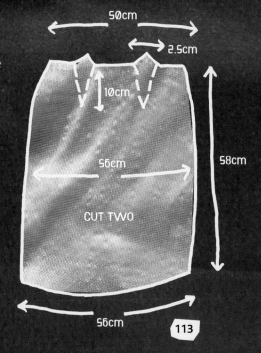

(THREE NEEDLES)
- 120cm x 70cm of crêpe-back satin
- 1 x 18cm zip

♥ Here's what to cut out twice (see picture):

It might be a good idea to tack this skirt up before you machine-stitch it. You want it to be figure-hugging, so tweak it and take it in a little until it is JUST right.

50cm

2.5cm

10cm

56cm

58cm

CUT TWO

56cm

- Follow all the steps for the A-line skirt on page 111, EXCEPT for the side with the split. For this:
- ♥ Start sewing the seam 20cm up from the bottom of the skirt (that's not a hard-and-fast measurement, that split can be a lot higher, just add on extra centimetres).
- ♥ On each side of the split, turn under a skinny little hem, and press.
- ♥ Then turn in a further hem, so that it sits nicely with the side seam.
- ♥ Once you're happy that it does, sew both sides of the split, and... you've guessed it... PRESS.

 ♥ The next step is to fall in love with Jack Lemmon. ♥

All Dressed Up

How to make a whole heap of genius frocks

Coco Chanel once said that fashion was both caterpillar and butterfly. 'Be a caterpillar by day and a butterfly by night,' she maintained. 'There must be dresses that crawl and dresses that fly. The butterfly does not go to the market, and the caterpillar does not go to the ball.' Like all advice, this is good if you pick the bits you like the sound of and pretend that you haven't heard the bits that you don't. There is nothing wrong with wearing a mermaid evening dress made of tulle and sparkles while perusing the shelves of the supermarket, if you are of a showy-off, courageous disposition. And it is always nice to have a dress that makes you feel that you should be famous. If I were choosing though, I'd always, always, nearly always pick the caterpillar dress, especially if it were made in fine summer cotton with a print of umbrellas or Art Deco flowers or little blue birds. Or I might pick a caterpillar dress with pretensions towards its next life as a butterfly...a simple dress in a more eveningy fabric – silk or taffeta – and that would be a perfect going-out-on-the-town cocoon, particularly if I were wearing rare-occasion high-heeled shoes with little metallic wings at the ankle.

I like the idea of naming dresses too. Aristocratic couturier Lady Lucy Duff-Gordon got bored with just calling her gowns 'the black velvet one' or the 'pale-green one' so in 1912 she decided to add a touch of the dramatic, and christened her collection 'Gowns of Emotion'. Individual creations were gifted with titles like 'When Passion's Thrall is O'er', 'Give Me Your Heart' and 'Do You Love Me?' Very First World War débutante. The Twenty-First-Century Girl would more likely need:

■ **The Alibi dress**, with many secret pockets containing lots of receipts, cinema-ticket stubs, bus tickets with the time printed on them and a TV listings page, in case you're accused of something and need proof that you were elsewhere when the crime/indiscretion was committed.

■ **The Carbon Footprint dress**, home-grown, hand-woven, hand-sewn, dyed with nettles and decorated with rowan berries, leaves and thistles.

■ **The Future Perfect dress** – limitless possibilities! – for girls who are stuck in the past.

TOP TIP More of a quick reminder really. Always make your dress too long to begin with. It's easy to shorten something, but making something longer can be a little trickier. But if you have chopped away too enthusiastically at the end of your frock, don't despair, you can always make a feature of the very thing that has turned awry. Sew a thick or thin band of contrasting fabric along the bottom, and then make a little rosette out of that fabric, and pin it to the shoulder of your frock; that way it'll look like you did it deliberately, with care and forethought, not to disguise an OOOPS moment. Or maybe add some fringe benefits. Hurry along to the local haberdasher's, invest in a couple of metres of tasselled trim, and tack it to the bottom of that pesky hem. I'd even be tempted to add a big row of knitted rib or purl to the bottom, and accessorise it with a knitted belt (see page 203). But sometimes the dress is just too darned short for any of these face-saving measures. So take the scissors to it, and turn it into a top.

Caterpillar Frocks...

A Medical Emergency Dress

This is a pull-over-the-head dress, with no zips, buttons or fasteners of any kind. It's inspired by surgeon's scrubs, and is perfect for watching medical dramas on TV, with a first-aid kit by your side packed with snacks and a flask of restorative, hot, sweet tea. This dress looks shapeless off, but tied with the sash belt from Chapter Six (see page 156), it looks lovely, especially if you make it in the colours of elegant French macaroons from posh Parisian bakeries.

✚ Fold the fabric for the dress in half, right sides together, making sure that the grain line is nice and straight. With tailor's chalk, draw an outline of the dress on the fabric, just like the picture here.

✚ Cut out.

(ONE NEEDLE)

- ■ 150cm x 150cm of fabric, for the dress
- ■ 1 card of bias binding (I used three different colours of bias binding in two different sizes – thin pink and lilac for around the sleeves, and fatter aqua blue to decorate the neck, but you could use any colour combination you like, or just the one.)
- ■ 150cm x 100cm of fabric, for the belt

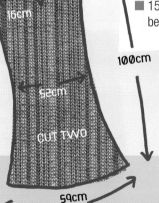

20cm

16cm

100cm

52cm

CUT TWO

59cm

- Zigzag all the raw edges.
- With the right sides together, stitch the shoulder seams 1cm from the edge.
- Sew up the side seams, right sides together.
- Try the dress on, and see what you think. You can take it in a bit if you think it looks too baggy, but not too much because you still need to be able to pull it on easily. The wide shoulders should drop down a little and look just like cap sleeves.
- If you do decide to take it in, you're probably going to have to re-do the side seams, zigzagging, pressing and all.
- Zigzag the 'V' at the front and back. Do a couple of rows of straight stitch along the bottom of the 'V's to make them more secure.
- Sew the binding onto the 'V's, making sure that it overlaps at the bottom of the 'V' – this will help stop the neck from tearing.
- Stitch the bias binding around the sleeves.
- Do the hem.
- Make the sash belt in the same fabric; see page 156 for the recipe.

To give this loose dress a different look, don't use bias binding to finish off the edges of the sleeves and neck; use smaller zigzags on all the edges – this will leave the fabric nice and floppy. You can leave the sleeves like that, or fold them under and tie them up with a ribbon or a cord or rough fabric bows. Or you can make the dress flare out more by making the skirt bit much wider and gradually tapering it towards the waist. Remember to buy more fabric if you're going for this swirly option. And then add a drawstring to pull the dress in at the middle.

A Snail-Trail Dress

I always liked the idea of making a living dress. Not a dress for living in but a dress that was alive in some way. I read about designer Martin Margiela's decayed dress designs – he ornamented them with green mould, pink yeast and fuchsia and yellow bacteria. But I was thinking more romantically...a little flower garden around the hem, a line of growing moss on a cuff. I did get my living dress, but unfortunately it involved wildlife...

In my dad's garden there's lots of ivy, and underneath the ivy there were hoards of snails. We did a snail patrol and gathered them up and put them in carrier bags, and I headed to the park to release them into the wild. It was a lovely sunny day, and I was swinging the carrier bags as I walked and smiling at passers-by who didn't smile back. I couldn't work out why. I beamed, they shuddered; I grinned, they grimaced. It was then that I realised one of the snails had escaped from the bags and was crawling up the sleeve of my frock. You would think that I'd go off the idea of a living dress after that, but I did quite like the silvery snail trail it left behind.

A Dress That Is in Cahoots With the Sun

This dress has a drawstring top to leave your shoulders and arms bare, with lovely ribbons to keep the dress on.

* Fold the fabric in half, right sides together.
* Draw this truncated-triangle dress shape onto the fabric with tailor's chalk and a ruler (see picture) on the wrong side of the fabric.
* Cut round the outline.
* Sew the side seams, right sides together, stopping three-quarters of the way up on both sides.
* At the top of the dress, turn a skinny hem to the wrong side of the dress, and press.
* Turn a skinny hem on the unsewn bits of the side seams, and press. Turn a further 1cm under, and sew it.
* Head back to the top of the dress, and turn under a bigger hem...about 4cm on both bits.
* Sew it.
* Thread the ribbons through the top.
* Try the dress, tie the ribbons in bows over your shoulder, and decide on the length.
* Do the hem.

44cm

CUT TWO

56cm

(ONE NEEDLE)

■ 150cm x 150cm of fabric (I used 100% cotton in burnt orange printed with a flower that looks like a thistle in creamy white with red-orange leaves.)
■ 200cm of ribbon, for the straps, cut in half

Instead of using two bits of ribbon, one long length of 2m will do instead. Thread the ribbon through the casing, and tie a one big bow on one shoulder. Add charity shop crochet doilies as pockets, or sew nice slouchy pockets into the side seams.

TOP TIP A plain fabric dress can be livened up with some appliquéd flowers. Trawl through your pile of fabric. Pull out a scrap that's printed with large flowers, cut around them, and zigzag the edges for neatness. Sew onto the frock. Lacking the necessary floral print? Get any old fabric, and cut it into flower shapes, and then maybe add a few green leaves and some glinting sequins.

And if busy prints give you a headache, why don't you choose one shade of a clear, delectable colour – cherry red, apple green – and it will be as refreshing as a sorbet.

A Pocket-Sized Tutorial

■ Try on the dress (or skirt), and pretend you're shoving your hand into your pocket. Place pins to remind you where you'd like it to go.

■ With a seam ripper, carefully undo the side seams there, about 21cm should do the trick.

■ Cut out two shapes in either lining material, a contrasting fabric or in the material that you made the dress in (see pic), a sort of kidney-bean shape, with that weird little extension. Zigzag the edges.

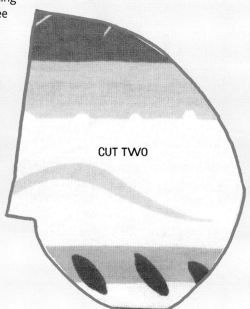

CUT TWO

■ Tack the pocket nearly all the way around, with the right sides together. A 1cm seam will be fine, but don't sew the weird little extensions. Once it looks nice and neat, you can machine-stitch it.

■ Next, turn the dress inside out. Tack the pocket to both edges of the open side seam.

Try on the dress, and see what you think.

■ Then stitch the pocket in place, taking care not to sew the pocket opening up. Reinforce the tops and bottoms of the pocket, by stitching back and forwards a few times at the corners.

A Dress With a Fake Smocked Top

Smocking is an elaborate technique to gather up fabric...the windows of expensive children's shops have row upon row of dresses with embroidered, puckered bodices, which look lovely, but take weeks to do. Take the shirring-elastic short cut instead. It's quick and easy and just as pretty. Make a frock for you, and a tiny version for your niece.

(TWO NEEDLES)
- 200cm x 150cm of fabric
- 1 or 2 spools of shirring elastic

- Cut the fabric in half, so that you have two rectangles.
- At the top of each piece, turn over a 2cm hem. Press. Sew.
- Get a bobbin, and hand-wind the shirring elastic onto it, stretching the elastic just a little bit as you wind. Use ordinary thread on the needle of the machine.
- Adjust the stitch length – the longer the stitch, the tighter the shirring's gonna be, which is a good thing.
- Do a little trial run of a few rows of shirring on a spare bit of fabric to see how it looks. If the elastic looks too loose, tighten the screw on the bobbin case. (Can't recall how to do it? Turn to page 44.)
- If you have steady hands, you can just start stitching. If you feel a little nervous, draw a series of lines with tailor's chalk and a ruler on the front of the fabric as a guideline. The more space between the rows of stitching, the looser the ruching will be – leave at least 1.5-2cms between rows.
- Start the first row of shirring just under the top hem, and leave a tail of thread and elastic when you reach the end of the row.

- Start on the next row, and pull the fabric taut as you sew to keep everything even. Once again, leave a tail of thread and elastic.
- Do another row, and another, and another, and another, so that the bodice is stretchy.
- On all the rows, tug the shirring elastic and thread to tighten them. This makes for a snug fit. Then knot the thread and the elastic at the end of each row.
- Take out the bobbin with the shirring elastic, and replace it with ordinary thread.
- Sew up the side seams, right sides together.
- And then do the hem.

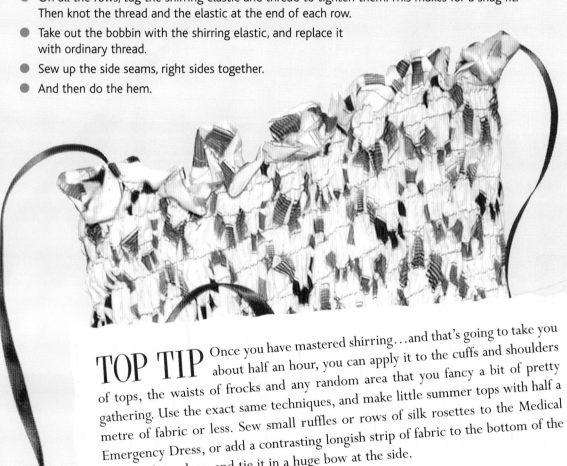

TOP TIP Once you have mastered shirring…and that's going to take you about half an hour, you can apply it to the cuffs and shoulders of tops, the waists of frocks and any random area that you fancy a bit of pretty gathering. Use the exact same techniques, and make little summer tops with half a metre of fabric or less. Sew small ruffles or rows of silk rosettes to the Medical Emergency Dress, or add a contrasting longish strip of fabric to the bottom of the top, stitch in place, and tie it in a huge bow at the side.

Old-fashioned **style guides** dish out advice about wardrobe staples – it is apparently indispensable to own matching gloves, hat, shoes and handbag in black and brown, with a beige set of the same for the more summery months. Cocktail dresses should be décolleté, and for luncheon appointments, white wool is the way forward. I just have a few words to say about that: cherry tomatoes, red wine, beetroot sandwiches. But I do have a wardrobe staple...

the A-line dress.

An A-Line Dress

■ Cut out the fabric like the picture:

The next step is up to you. If you're feeling a bit of shivery trepidation, tack as you go along, that way any mistakes are easily undone. Otherwise, what the hell, head straight for the machine.

(TWO NEEDLES)
■ 150cm x150cm of fabric
■ 1 x 56cm zip

■ Zigzag all the edges. (And take it for granted that you have to keep on PRESSING.)

■ Do the bust darts.

■ And put a centred zip in the back. (For a reminder of how to do this, turn to page 109.)

■ Sew the shoulder seams 1cm in, right sides together.

■ Then the side seams, right sides together.

■ Try the dress on, and see how it's looking.

■ Do the hem.

Now you've got another choice. You can...

■ Sew bias binding around the neck and the arms and leave it at that.

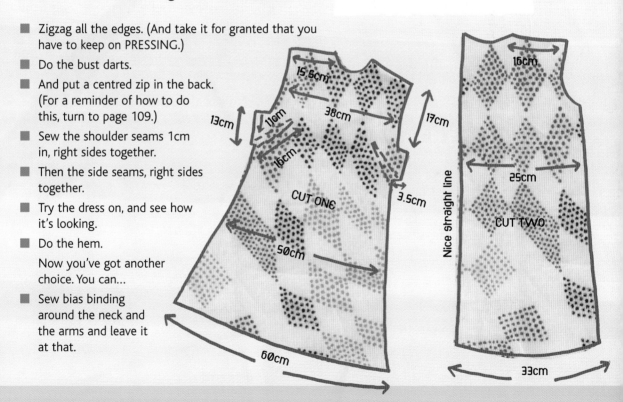

15.5cm 38cm 17cm 13cm 11cm 16cm 3.5cm CUT ONE 50cm 60cm

16cm 25cm Nice straight line CUT TWO 33cm

131

Or...

▲ Cut out neck and arm facings like these:

FRONT

CUT ONE

CUT TWO

To follow the curve of the neck plus 2cms extra - 1cm on each end

To follow the curve of the back of the dress plus 2cms extra - 1cm on each end

Sewn together they look like this

▲ Sew the front and back neck facings together at the side seams, right sides facing.

▲ Then sew them around the neck of the dress, right sides facing again.

▲ Cut little triangles out, to make it lie flatter when you flip it over. Be careful not to snip into those stitches.

▲ Turn it over. With any luck, the neck should look beautifully tidy and neat.

▲ Do the same with the arm facings.

Oh! And if you were feeling really, really fancy, you could add a little interfacing to the facing. Just iron some onto the wrong side of the facing before you sew it to the neck of the dress.

Sleeve Notes

I often get crushes on particular bits of clothing. At the moment it's sleeves. I love the look of sweet puffed sleeves or a three-quarter-length sleeve on a simple dress. Or a loose long sleeve with a little elastic casing at the cuff to make it fit snugly at the wrist. But my very favourite sleeve at the moment is one that is huge and sweeping, the sort of sleeve that you have to roll up to stop it from trailing in your soup. Even though I love sleeves, I don't actually like making them all that much. I always attempt to hurry the process up, end up feeling pretty harried, and then have to attack what I've just done with the seam ripper. There is a simple solution to this not-so-tricky dilemma and that is not to get stressed, and to allow lots of time to get the job done.

The other thing to remember about making sleeves is that they take up a surprising amount of material. For short sleeves, add about an extra 25cm, and if you're going for longer and wider sleeves, add in 50cm–1m of extra fabric.

Simple Short Sleeves

- ■ 38cm x 26cm of fabric

- ■ Cut out two shapes like this:
- ■ The tricky part is getting the curve of the sleeve top to fit neatly into the armhole. To help, sew two rows of running stitch around the cap of the sleeve (known, by seamstresses, as 'ease'). Do the first row about 1cm in from the edge and the second a little bit away from that. I like to do this bit by hand; there's something fun about swishing a line of running stitches at top speed. But you can, of course, do them on the machine.

- ■ Next, sew up the side seam, right sides together. And then turn the sleeve the right way out.
- ■ Have a biscuit before the next bit. OK.

- ■ With the dress wrong side out, pop the sleeve right inside the armhole, right sides together.
- ■ Pin the sleeve into the armhole... keep the pins far apart.

■ Pull on the running threads to help **EASE** the sleeve, and even out the gathers. Then tack it in place.

■ Try the dress right way out, to check if the sleeve feels comfortable. Make sure you are actually able to move your arms. I have sewn many dresses where my arms were as good as glued to my sides. Any lifting motion made the sleeve rip away from the rest of the dress, so that there was a **HUGE** hole under the arm. Classy!

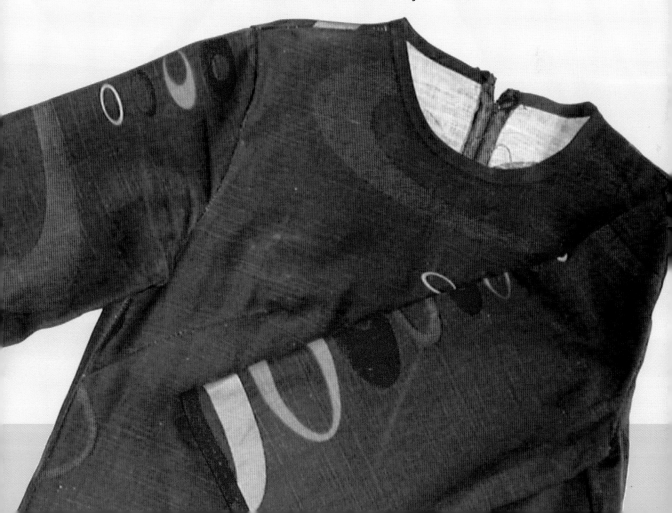

- If it feels fine, sew it in place, starting at the underarm and working your way all the way around the armhole.
- Do another line of stitches a little way in to reinforce the sleeve.
- If it feels a little bulky, you can trim away the excess fabric close to the second line of stitching.
- If the sleeve feels tight, undo the tacking, adjust the gathers, and tack again, until it feels fine.
- Press.

To make swishy sleeves, cut out this kind of shape:

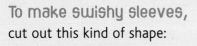

You can sew up the side seam, but it looks very glam if you don't. Just sew some bias binding along the sleeves' side seams to make it look extra pretty.

TOP TIP Björk once wore an Alexander McQueen dress when she was on stage. It was made of dyed red microscope slides, sewn on in iridescent, tinkling layers. When she danced the dress became a percussion instrument. To get a jingle when you walk, sew tiny silver bells to the hem of your skirt.

Butterfly Frocks...
or Lazy Red-Carpet Dresses

These dresses are fluid and drapey, and made in liquid-look satin. Liquid satin is expensive, liquid-*look* satin isn't; the one I used cost about £1.50 in a closing-down sale. But John Lewis does some, starting at about £6/m and going all the way up to the heady sum of £39/m. Unless you really are heading onto the red carpet to collect an Oscar, I'd stick to the cheap chic price bracket.

A Dress for Modest Girls

- Cut the satin into two. Each piece should be about 75cm in width.
- Zigzag all the edges, except for the two bottom ends.
- Put the right sides of the satin together. Sew a 1cm shoulder seam on the left and right-hand sides 15cm in from each edge. Leave enough room for your head.
- Sew up the side seams, right sides together. Leave enough room for your arms.
- Try it on. It's going to look like a floaty sack, but wrap the hasty belt around your waist, and fasten with the brooch; it suddenly looks quite glamorous.
- Decide on the length.
- Cut it to almost the right length, and zigzag the edges.
- You can turn up a skinny hem if you feel like it, but you could leave it a little frayed, that'll look pretty too.

(ONE NEEDLE)

- 150cm x 200cm of liquid-look satin
- 1 wide piece of starchy fabric (to use as a quick-fix belt), a wide velvet ribbon or a row or poppers
- 1 brooch (if using the fabric belt option)
- Sequins to decorate

Or...

- Leave a gap in the side seams on both sides, at about waist level.
- Tie a wide velvet or satin ribbon around your back *under* the top, and then thread the ribbon through those little slits, bring it to the front, pull, and knot. This leaves the dress nice and billowy in the back, and pulled in at the front.
- Make up dress, pull it on over your head.

Or...

- Grab ahold of both sides of the top at the waist, and pull them forward to the front, to make two big tucks. Put in a few pins to mark the place where the tucks should go.
- Sew a row of little poppers on either side of the dress.
- Pull the top back over your head, and fasten the poppers. I like the way that the loose dress is now quite fitted. Play around with where you place the poppers to get different looks.

And then get out the sequins. I like the idea that they were originally made of fish scales and were used to recreate the way the sun spangles on the sea. Sew a row of sequins or a slapdash scatter of them – millions on a dress do look brilliant, but it's going to take years to finish. Elizabeth of wraparound-skirt fame sewed the sequins on her thirties wedding dress in an intricate herringbone pattern. The sequins were antique and small, and late at night, after she'd finished stitching, all she could see when she shut her eyes were lines and lines of tiny dancing sequins. Even when she was asleep, they came into her dreams. 'Just too many bloody sequins,' she says.

A Dress for (Flaunt-) It Girls

- Cut the satin into two, as for the Dress for Modest Girls.
- Zigzag all the edges, except for the two bottom ends.
- Put the right sides of the satin together. Sew a 1cm shoulder seam on the left and right-hand sides 15cm in from each edge. Leave enough room for your head.
- Don't sew the side seams.
- Get the four long lengths of ribbon, and pin one length to each of the four sides at waist level.
- Pull the dress over your head, tie the ribbons from the front bit around the back of your waist, *under* the satin, bring the ribbons from the back, and tie them over the *front* of the frock. That's it. (The dress can be made into an empire-line one if you move the ribbons to just under your bust.)
- Take off the dress, and sew on the ribbons.
- Do the hem.
- Head for a red carpet.

(ONE NEEDLE)

- 150cm x 200cm of liquid-look satin
- 1 roll of wide double-satin ribbon, cut into four

TOP TIP Take scissors to the neck to change the shape, cut out a semicircle or a deep 'V', zigzag those edges for the distressed, aristocratic look, or bind with satin or velvet ribbon. Or you could gently roll the edges back to the wrong side, and hand-stitch them in place.

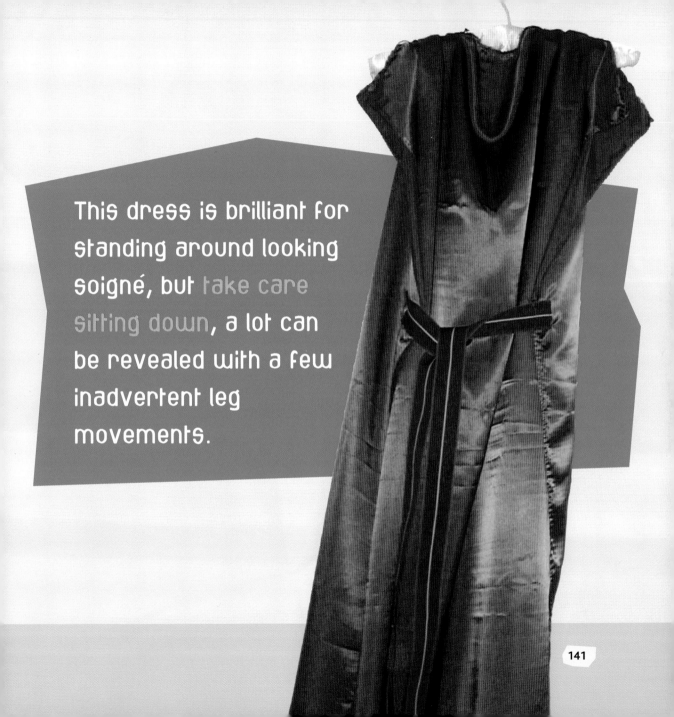

This dress is brilliant for standing around looking soigné, but take care sitting down, a lot can be revealed with a few inadvertent leg movements.

The Two Days to Go Party Dress

Make this in taffeta or satin or silk or slinky velvet or some beautifully patterned fine cotton in colours that even sound romantic – ink black, old rose, delicate cocoa, midnight blue, pale violet, ivory, smoke. It's based on my wardrobe staple – the A-line dress – but with a slashed 'V' neck, and a row of delicious rough-and-ready pleats around the hem for added party fun. The dress is quite loose, but you can make it less figure-skimming and more figure-hugging by taking it in at the sides. Add the flowers from Chapter Six (see page 159) around the neck or the shoulders. They don't have to be fine and finished – make them instead in tattered tulle or frayed brocade. A ruffle falling from the shoulder looks pretty too.

(THREE NEEDLES)
- 150cm x 250cm of lovely party fabric
- 1 x 56cm zip
- 1 card of bias binding

- The main body of the party dress uses the same pattern pieces as for the A-line dress (see page 131). Cut them out.
- And then cut two long strips of fabric 10cm wide, about 150cm long. (If you want longer pleats, cut the strips wider than 10cm.)
- Zigzag all the edges. (And take it for granted that you have to keep on PRESSING.)
- Do the bust darts.
- Put the zip in.
- Cut a deep 'V' into the front of the dress.
- Zigzag around the 'V'.
- Sew the shoulder seams 1cm in, right sides together.

- Then sew up the side seams.
- Put the dress to one side for the moment, and turn to the first of the long strips of fabric.
- Pleat all the way along, putting pins in as you go to stop the pleats from un-pleating (just as in the Rough-and-Ready Pleated Skirt on page 106).
- Sew across the top of the row of pleats, as close to the edge as you can.
- Then sew down one side of each pleat, so that they lie flat. Stop about 5cm from the bottom.
- Do the same with the other long strip of fabric. Press the pleats.
- Pin a row of pleats to the front and back hem edges of the dress on the right sides of the dress.
- Try the dress on, and see how it's looking.
- If you're happy, sew the pleats to the front and back of the dress.
- If you're not happy, play around with the pleats and pins until you are.
- Now you can sew bias binding around the neck and the arms and leave it at that.

Or...

- ▼ Cut out neck and arm facings like these:
- ▼ Sew the front and back neck facings together at the side seams, right sides facing.
- ▼ Then sew them around the neck of the dress, right sides facing again.
- ▼ Cut little triangles out, to make it lie flatter when you flip it over. Be careful not to snip into those stitches.
- ▼ Turn it over. With any luck, the neck should look beautifully tidy and neat.
- ▼ Do the same with the armholes.

Or...

〰 My favoured option – go with the elegantly fraying zigzagged edges.

Fripperies and Fineries

How to make a bunch of accessories

I have always loved the idea of a dressing-up box. The sort that you could delve into and come up with a belt from a far-off country or an orange velvet opera cloak left behind by Great-Aunt Agatha. The bottom of the box would be lined with ancient patchwork quilts, just waiting to be cut up, and like geological strata, there'd be significant fashion finds at every layer: twenties silk nighties with frayed hems and shoulder straps, nipped-in-the-waist forties suits, a selection of fifties summer frocks with quirky fruit prints and a Courrèges dress with a scalloped hem and Perspex buttons.

We didn't have a dressing-up box when we were little; instead, we made do with wandering around Granny's garden in Mum's lovely watered-silk wedding dress, getting it covered in grass stains, or parading along walls in

a collection of coats from the sixties that my aunts had left on the back of the bedroom door. The thought of those coats gives me a pang now, because I realise that they were beautifully cut wools and tweeds the colours of heather and smoke, long saved for, and when I was walking along walls in them, I thought they were funny. I covet them in hindsight. This chapter is like a dressing-up box: there are a few lovely things in it and some stuff that's meant to make you laugh.

Design Your Own Fabric

Potato Prints

Remember potato prints and how one Christmas you revived that lost primary school art and spent a week making all your cards and wrapping paper, industriously splodging triangular pine trees and glittery baubles onto sheets of off-white cheap craft paper and brightly coloured card? Here's a chance to do a bit more showing off. Apply the exact same technique to create a one-off piece of material, designed exclusively by you, or with the help of any friends who might be skulking around your flat looking for something to do on a rainy Sunday afternoon. Embrace the chance to get messy!

- Cheap cotton or calico (I like Ikea's Bomull™, about £1.60/m.)
- Potatoes (Nice fresh ones are miles better than those old rubbery ones with lots of eyes, like aliens from another planet.)
- Pots of fabric paint (I have used enamel paints and metallic paints, and my friend Dan in a moment of drunken inspiration decided to add a household-emulsion decoration to the T-shirt he was wearing. As it dried, the paint crinkled and cracked like a very old painting.)
- 1 felt-tip pen
- 1 very sharp knife
- A few old saucers to slosh the fabric paint into

- Slice the spud in half as cleanly as possible; a nice flat surface works better than a wonky one.
- Blot it with a bit of kitchen paper, and mark out a design with the felt-tip pen.
- Take the knife, and let potato surgery begin. Splice away the parts you don't want printed. Cut at least 1cm in, as the print will be much clearer: shallow spud = gloopy design.
- Load up the spud with some colour, and start printing. If you're feeling hesitant, practise on a bit of paper first – otherwise, head straight for the Bomull.

I probably should have said at the beginning that it's a good idea to spread some newspaper around to avoid ruining the floorboards. It is too late for my carpet; I ran to answer the phone in the middle of a potato-print party...now there are metallic-gold footprints over the floor. (They looked quite good on the cotton though.)

- Hang the fabric up to dry.
- Make some chips from the leftover potatoes while you're waiting.
- Iron the fabric to fix the colours. (It's always best to check the instructions on the jars of paints to see what they recommend.)

Raid the fruit bowl or vegetable drawer for more things to chop in half.
Pepper, pear and apple shapes look lovely on the creamy-coloured cloth.

Modern Art

Obvious, but fun nonetheless.

Splatter fabric paint over the fabric in a Jackson Pollock style. A delicate touch is not required; the heavy-handed approach is the one to go for here.

- Fabric paint
- Cheap fabric
- Paintbrushes or water pistols

Or maybe load up some pound-shop water pistols with watered-down fabric paint, and start squirting. When it's dry and the colour's fixed, you can transform your freshly designed fabric into a lining for a sweet little bag or a quirky short skirt.

A brief encounter between some bright wax crayons and a rather plain but interesting dress

I made a nice forest-green wraparound dress. And then I melted wax crayons in a little saucepan (each colour separately), and splashed and dripped them over the frock. The frock is now forest green, with lovely smooth dribbles and bubbles of cerulean blue, dark fuchsia and lime green. I haven't washed it yet, but I have an inkling of what will happen.

Obi-Style Belts

Who hasn't looked at pictures of Japanese kimonos fastened with gorgeous Obi belts and not felt goose bumps and more than a little covetous envy? The real thing costs a fortune. Traditional Obis were 30–36cm wide and over 3m long, and were wrapped several times around the waist, then tied at the back with a huge bow. Ladies would use all that material as a handy storage place, slipping fans, powder compacts or a hanky behind the folds. Here are three more compact versions, which are inspired by the originals but use a lot less fabric.

See below. The lilac, purple and pink belt is made from an old curtain. The underside is a snippet of pink crinkle fabric that I once bought 5m of in a sale. (There's about 4.5m of it left.) The green belt opposite was made from leftover dress material. (The underside looks like the kind of fabric that airhostesses' blouses are made from.)

Belt One:
to Be Worn on the Hip

Measure your hips before you start, and then add a few centimetres. The belt isn't supposed to fit tightly; this is a more louche, low-slung look.

- Zigzag all the edges.
- Sew a few rows of sequins on both width ends on the outside.
- Tack the topside to the underside. And then machine-stitch them together, wrong sides together, as close to the edges as possible.

(ONE NEEDLE)

- 2 x 10–20cm-long, 150cm-wide strips of fabric (Your choice is in no way limited to pretty retro florals – stark geometric patterns in bold colours would look brilliant, as would bright spots, cute cartoons and rich brocades. One length is going to be the outside…a fabric with a bit of firmness will give the belt a nice starchy feel, the underside can be soft and supple, but equally pretty, even though you can't see it when you wear the belt. I like the idea that it's a hidden detail that only you know about.)
- Some glittery sequins (optional…but they do look really, really lovely!)
- 1 card of wide bias binding in a complementary or clashing colour (or a few metres of wide ribbon)
- 80cm of ribbon or cord

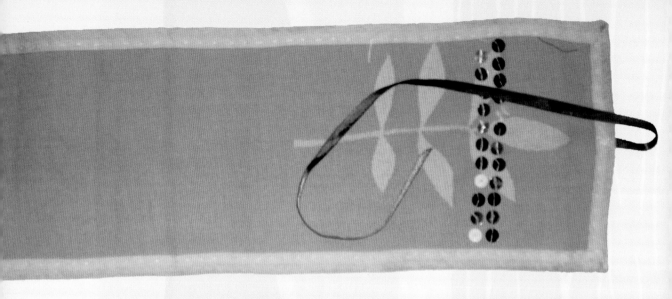

- Encase those zigzagged edges in the lovely bias binding. and sew it on all around the belt.
- Cut your ribbon into two 40cm pieces. and stitch one bit of ribbon to the middle of each end of the belt.
- Sling the belt loosely around your hip; tie the ribbons into a bow to hold it in place.

Or use just one piece of wider fabric - 30cm x 150cm of fabric - for this version:

- Zigzag the edges that look liable to fray.
- Sew on the sequins.
- Turn a 1cm hem onto the wrong side on all four edges, and press them.
- Fold the belt in half lengthways, wrong sides together, and sew it.
- Sew the bias binding in place, and attach the ribbon.
- Instead of sequins, embellish with little buttons or silky tassels or brightly coloured tiny pompoms.

Belt Two:
Elegantly Waisted

This belt goes right around your middle, and ties up with wide satin or velvet ribbon, and is very ladylike indeed.

- First, zigzag the raw edges of the fabric.
- If you're going to use interfacing, now is the time to add it – iron it to the wrong side of one of the pieces of fabric.
- Turn a 1cm hem onto the wrong side on all four edges of one piece of fabric, and then press the hems.
- Do the same with the other bit of fabric.
- Cut the ribbons in half.
- Sew the long sides of the belt together, wrong sides facing, as close to the edge as you can, **BUT** leave both ends open.
- Place a length of wide and of thin ribbon on each of the ends, about 1.5cm in, and then sew up the ends with a neat row of stitches on the right side of the fabric.

- 2 x 20cm-wide strips of starchy fabric, just long enough to wrap around your waist, plus a couple of centimetres
- Some iron-on interfacing if you want the belt to be even more structured
- 200cm of wide ribbon
- 200cm of thin ribbon

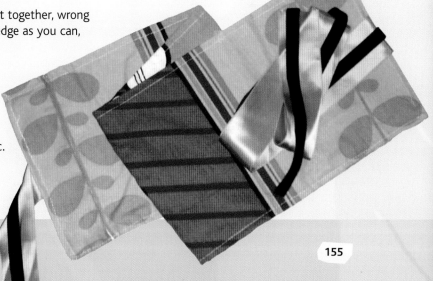

Belt Three: the Sash

This is an extravaganza of a belt. Wrap this belt around your waist, and tie it in a big bow at the back, or have the ties to the front, and let them dangle like a geisha pirate. Because there's a lot more fabric here, a crisp, thin cotton would be a good choice of material, or something with a little bit of stretch that'll be less bulky than a thick brocade or a piece of very fat furnishing fabric.

- Zigzag the edges of all of those four strips of fabric.
- Then lay them out on the floor to see which way they look the best.
- Get the first two strips, and put the right sides together, then sew a 1cm seam along the widths. Press open.
- Join another strip on in the same way, until all four pieces are sewn together in a big, long strip. It is going to turn into a belt, I promise you, even though at the moment it looks like a welcome-home banner for your auntie who eloped with a tattoo artist from Canvey Island.
- Have a bit of a rest before tackling the next few bits.
- Press a 1cm hem under on the wrong side of one of the width ends.
- Now fold the whole shebang in half lengthways, right sides together.
- At regular intervals, pin all the way around to it to stop that loooooooooooong bit of fabric flapping apart. **DON'T pin the edge with the pressed 1cm hem.**

(TWO NEEDLES)

- 4 strips of fabric, each 18cm x 120cm. (Here's a chance to play around a little…you could use two or three differently patterned materials, various shades of one colour, or a mix and match of anything that you happen to have lying around. Just one colour would be fine as well. And if you want to add a little bit of firmness to the cotton, get some iron-on lightweight interfacing, and iron it onto two of the four strips.)

- Then get sewing. Girl racers can put their foot down on the sewing-machine pedal and sew a speedy row of stitches around the whole belt 1cm in along each side, leaving the end with the 1cm hem stitch-free.
- Turn the belt right side out.
- Sew a row of stitches along that final width, on the right side, to finish it all off nicely.
 If you feel like it, you can zoom a few rows of decorative stitches all the way around the belt. Ladies of a more sedate disposition can take a more leisurely approach and sew nice and slowly.

If you're anything like me, you will have loads of leftover bits of fabric in lovely patterns that are too nice to throw away and metres of ribbon that you bought because you couldn't resist the colour. And although they look nice all mixed together on a shelf, they'd look even nicer made into...

Roses, Rosettes and Corsages

A Rosette Made From Ribbon

- Pleat 40cm of the ribbon and then shape it into a rough circle.
- Leave the unpleated 10cms to make a nice decorative tail.
- Take the two circles of felt and the circle of interfacing. Sew them together, with the interfacing in the middle, then sew the pleated ribbon around the felt circles.
- In the gap in the middle sew on a button.
- Sew a couple of buttons onto the tail, too, if you feel like it.
- Put a brooch back on the back.

(ONE NEEDLE)

- 50cm of pretty wired ribbon. (This is ribbon that has a thin line of wire on both its sides; it's nice and bendy, and you can shape it easily.)
- circles of felt
- circle of interfacing
- a few buttons
- brooch back

A Taffeta, Satin or Silk Rose

- 🌸 Zigzag the edges.
- 🌸 Hand-stitch or machine-stitch a line of running stitch along one of the long sides a little way in from the edge, and leave a long tail of thread when you're done with the running stitch.
- 🌸 Tug on the tail of thread, and push the gathers right down to the other end of the strip. That far end is going to be the middle, so begin to roll up your flower from there.
- 🌸 As you're rolling along, stitch through the base of the flower every now and then to keep the stem nice and tight.
- 🌸 Keep on rolling and sewing, rolling and sewing.
- 🌸 When the entire strip is completely furled, sew a few more stitches from the outer edge through to the stem to make it all shipshape and steadfast.
- 🌸 Snip the thread, and sew a brooch back to the base.

(ONE NEEDLE)
- ■ About 5cm x 80cm of dashing fabric
- ■ 1 brooch back

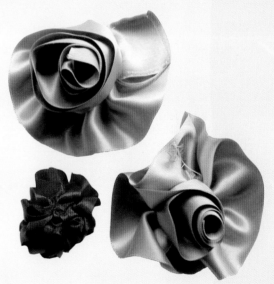

Try the same thing on 50cm of thin ribbon:

❖ Sew a line of running stitches in the centre of the ribbon, and leave a long tail of thread when you're done with the running stitch.

❖ Tug on the tail of the thread, so that the ribbon furls up tightly.

❖ Use the tail of thread to sew the two ends of the furled ribbon into a circle shape. Make sure it's nice and secure.

❖ Sew the pretty little roses onto hairclips, safety pins, chignon pins or even earring backs.

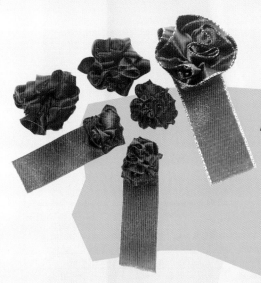

And you could use wide ribbon and make bigger rosettes and attach them to your shoes, and look just like the fine doublet-and-hose-wearing gentleman of the seventeenth century.

A Corsage

- Cut the fabric into a circle.
- Zigzag the edges of the circle for a neat look, leave them raw and it'll look distressed but in a good way.
- Near the middle of your fabric circle, draw a circle with some chalk. Do a row of running stitch around the chalk outline. Once again, leave a long tail of thread at the end.
- Tug on the tail of the thread, so that the fabric scrunches up into a flower shape.
- Use the tail of thread to keep the flower scrunched up by sewing a few stitches at the back of the flower.
- Get a big button, and stitch it in the centre of your blooming fabric.

Or you could cut out a bunch of wavy-edged circles in different sizes and patterns, and pile them together, with the largest on the bottom. Needle and thread them together, and add a badge to the middle.

For more flower fun, see Chapter Seven

(ONE NEEDLE)
- 1 small piece of fabric
- Chalk
- 1 button

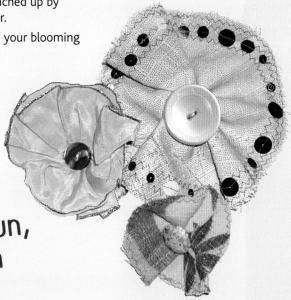

A Shoulder Cape, Plus a Magician's Trick

There is something irresistible about a cape. Fairy-tale heroines wear them in the woods; chorus girls wear them on dates; superheroes, swashbucklers and highwaymen cut a dash in them.

This little cape is pretty much reversible, so use two lots of lovely fabric.

(TWO NEEDLES)
- About 150cm x 80cm of each fabric, plus a little bit more if you're thinking of putting on a collar and some interfacing
- 1 drawing pin
- Tailor's chalk
- 65cm of string
- 1 button and loop or 2 pompom ties

✦ Fold one piece of fabric in half lengthways, right sides together.

♠ Tie the tailor's chalk to the string...make sure that the string's length is now about 60cm.

✦ Drawing-pin the tailor's chalk and string to the corner of the folded edge.

♣ Use the string and chalk to swoop out a semicircle. Cut around it.

♥ At the top corner, cut out a much, much smaller semicircle. This is where your neck is going to nestle.

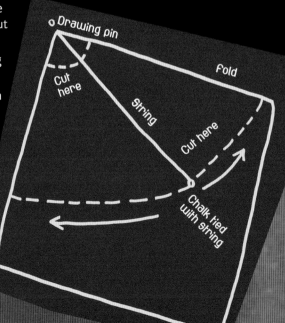

Drawing pin
Fold
Cut here
String
Cut here
Chalk tied with string

♠ Do the same with the other bit of fabric.

✦ Put them right sides together, and if you're feeling dithery, carefully tack all the way around, 1cm from the edge. BUT LEAVE A SMALL GAP at the centre back, either at the top or the bottom.

♣ If you're not feeling dithery, throw caution to the wind and machine-sew the seam in place. BUT REMEMBER TO LEAVE A SMALL GAP.

♥ Press the seams.

♠ And now, drum roll please, pull the right sides of the cloak through the gap. Hey presto, a lovely lined cape. All you have to do now is sew up the little gap, and attach the button and loop or the pompom ties.

To give this cape a little more definition, add darts to the wrong sides of both bits of fabric along the slope of your shoulders before you perform the inside-out magic trick.

To make a stand-up collar, cut out a strip of fabric 2cm longer than the neck edge. I quite like a big collar, but you could go for a skinny one. For a quite big collar, you'll need a width of about 18cm.

♥ Iron some interfacing to the wrong side of the collar.
✦ Press a 1cm hem around all the edges.
♠ Fold the fabric in half. Press.
♣ If you're feeling cunning, make a cape-and-collar sandwich – the cape is the filling – and sew it to the cape neck as close to the edge as possible. Sew up the little side seams of the collar.

Or...

♣ Pin the collar to the outside neck of the cape, right sides together, and machine-stitch in place. Then flip the collar over, and hand-sew the collar to the inside of the cape with little tiny hemming stitches.
♠ Sew up the little side seams of the collar.

Wear the cape with either a swagger or a sashay.

Suggested fabrics for the cape? Well, oyster-pink satin, apricot velvet, lilac crêpe, red linen (maybe with a little hood and a basket and a wolf). And if you're feeling Gothic, midnight-black silk velvet with party-shop spiders sewn around the neck as a sinister, furry ruffle.

Cheap Tricks

How to forage in charity shops and be cunning with other people's cast-offs

Charity shops, car-boot sales, jumble sales and auctions in out-of-the-way places can be a treasure trove for old fabric. If you get really lucky, you might discover a real vintage gem: a frayed forties tea gown, a sixties coat with original buttons or a crisp, floral, fifties sundress scattered with big yellow roses. Have a good rummage, but don't get your hopes up – clothes-shop owners and canny designers have usually been there before you and snaffled up all the good stuff. Now it's usually an unruly mix of Next and Gap cast-offs.

So don't just concentrate on finding the perfect vintage outfit. Other people's more quirky cast-offs can set your creative pulse speeding – Marni's Consuelo Castiglioni created a whole season's worth of summer clothes inspired by an appliquéd hessian place mat stitched with perky little birds which was picked up for a song in Portobello Road, and a flowery green swimming costume bought from a vintage store in LA.

If you do discover a lovely old dress or skirt, but it's in a massive size, and you're not, buy it anyway (as long as it isn't hideously expensive); you can adapt it or take it apart and make it into something else that fits.

You're more likely to discover a cute cushion cover that can be turned into a bag, or a curtain that can be made into a frock or a skirt.

Curtain Dresses

My favourite summer dress is made from a curtain that came from a holiday caravan in Margate, and cost about £2.50. I liked the fabric so much that I took many cheaty short cuts when I turned it into a dress, so that I could wear it ASA-humanly-P, using the very simple A-line dress pattern (see page 131). There was a very deep hem along the bottom of the curtain, so instead of unpicking it and ironing out the sewing marks, I made that the top of the dress, and used the hem as a sixties-style Mandarin collar. And the handy middle seam through the centre of the curtain became the centre seam of my dress (so far, no sewing at all, just a bit of cunning cutting out). Then I put in the bust darts, the zip, and turned it up. As this was a hasty production, I didn't zigzag the seams to neatly finish them off...so now they're getting a bit frayed, and the hem's bedraggled.

TOP TIP Try not to stand in front of curtains that your dress is made of...unless you are practising your camouflage technique.

With some dresses, you can claim it's a fashion-forward, cleverly deconstructed look, but on others, it just looks messy, so get zigzagging, or carry a small pair of scissors for an impromptu repair session.

Here's a quick reminder of how to make sure that deconstruction doesn't turn into dress destruction: tidy the edge with nice little zigzags, turn the edge under to the wrong side, and then sew in place. Press. It doesn't have to be a skinny little hem, you can turn under 2–3cm, but don't turn under too much, or the hem will start flapping down.

My other best dress is a more delicate affair. It's very fragile, with a climbing leaf pattern in a shimmery brown and a very, very pale green, which looks almost medieval. The reverse is beautiful too – if there'd been more material, I'd have made another dress with the inside facing out, but at the car-boot sale there was only one curtain left, bought for the princely sum of £1. Because the fabric's so delicate, I kept the cutting, sewing and readjusting down to a minimum. I sewed bias binding around the hem and neck and sleeves to stop them from fraying.

TOP TIP Old curtain material can be really scratchy and dusty, and not the kind of thing you'd want next to your skin. If it's heavy-duty cotton or something similarly crisp and hard-wearing, just bung it in the washing machine with lots of fabric conditioner for a few cool washes, and that will take the itchiness and scratchiness away, and add in some softness.

But be careful if the fabric is really old and fragile: a machine wash might be too harsh. Hand-wash instead with very mild washing powder. Use Marigolds if you're feeling squeamish.

Look Out for...

Old curtains, cushion covers and tablecloths or quilts with bold or pretty prints in unusual colours – designer Jessica Ogden made a hand-sewn top from an antique comforter, with the old darns and odd seams left in as interesting details. Aprons can be turned into bags; old headscarves can be made into bag linings. Keep your eye out for old dressmaking patterns too, but check the sizes: we've got bigger and taller since the fifties. Old-skool 12 would be an 8 or 10 nowadays. You can find cute knitting patterns in charity shops, sweet sixties sweaters and 'I've travelled the world' seventies chunky hooded cardies. I especially like those little craft magazines that have instructions on how to make felt animals, tea cosies and knitted ties. The colours are brilliantly bonkers, but sometimes they have good accessories – mittens on strings, cloche hats and crochet flowers. Chain-stitch a few in summery coloured yarns, and sew to the lapel of your jacket for a bit of cheeky chic.

Look out for knitting needles too, but check the tips. If the protective covering has chipped away, don't purchase them – the exposed metal will keep catching, and your wool will snag and fray, but not in a good way. Oddments and single balls of wool are always good to have, as are broken bits of jewellery, beaded necklaces, holiday key rings, button badges...in fact, anything that attracts your magpie eye can be transformed into something quirky and cool, and original.

Knitting wool costs a fortune, so look out for old hand-knitted jumpers or cardigans in gorgeous wool to unravel, even if they are in a truly ugly style. Here's how, as explained to me by the knitwear designer Ruth Herring: first, turn the jumper inside out, and carefully undo all of the seams. This might seem a bit tricky at first...you should have a back, a front and two sleeves for an ordinary sweater; a back,

two front panels, two sleeves and two button bands (usually) for a cardie. Start unravelling from the top. Hopefully, with a bit of searching, you'll be able to find the last cast-off stitch – undo it, and gently pull. With any luck, the jumper will start to unravel. Roll the wool up into a ball as you go. And because the jumper wasn't knitted from one giant ball of wool, expect to come to a temporary halt when you get to the bit where the new ball was joined. Unpick it, and start unravelling. Start your own new ball.

The unravelled wool will be WAVY, and I quite like it that way. But if you want to straighten things out, here's how to go about it: make each of your balls into 'skeins' by winding the yarn around your hand and elbow in a big circle. Get some snippets of brightly coloured acrylic, and fasten them at intervals around the yarn circle to hold the yarn in place. Put them in the machine on a very cool wash (not in any way hot, or the yarn will shrink). Hang your skeins out to dry, with a weight attached to the end – a can of baked beans will do the job – that way all the kinks will disappear. Wind it all back into balls, and knit a pretty new snood (see page 209).

DON'T BOTHER trying this with nylon or acrylic, it's just not worth the effort…it's as cheap to buy it new. Here's a simple sum to prove it: 1 x 100g ball of 'Super Craft' acrylic = 2 mittens, 1 scarflette and 1 small pompom. Cost: about £1.40.

For some knitty things, cheap yarn really is the way to go…pompoms, and mittens, and egg cosies. But if you've got your heart set on making a jumper that's going to last for years, it's best to choose a yarn that will last. Acrylic gets all baggy and bobbled if it's washed too much. A wool and acrylic mix will give you the best of both worlds. But treat yourself to something really lovely, and make a small winter scarf in cashmere or a little collar in Angora.

Reverse Engineering

■ Don't despair when your favourite dress or skirt gets worn out and shabby. Use it as the template to make a new one from scratch. Turn it inside out, and apply the rules of reverse engineering. With quick unpick in hand, carefully take out the zip and buttons, and then undo all the seams and darts. Get a big sheet of dressmaker's paper (a cheap roll of lining paper or taped-together newspaper would do the job too), and draw around each individual piece, marking in the position of any darts and the zip. The salvaged buttons and zip can be re-used when you embark on making a new dress.

■ This rule also applies to beautifully cut charity shop dresses that are hideous in colour or fabric...buy them, take them apart, and use the pieces to create something new in crisp linen, fine cotton or gold lamé. A friend of a friend has a wonderful collection of razor-sharp sixties dresses, A-line, with stand-up collars or kicky pleats in the skirts. All of them worse for wear...red wine down the front, or in yucky colours, or made up in static-electricity nylon (when you pull them on over your head, your hair crackles like a bad science experiment). She's a little reluctant to fully embrace reverse engineering, but there's an alternative approach to take: turn the clothes inside out, and draw around them, without taking them apart. Add on an extra few centimetres to the outline for the seams and the zip.

■ Another way of creating a really cheap and cheerful (and not stunningly accurate) pattern is to draw around yourself. For this you'll need a felt-tip pen, a big piece of paper and a friend. Lie on the floor with your arms out-stretched. Tuck your skirt or dress under your bottom, and then get a trusted friend to do an outline of you. The paper-doll you will provide a fairly good idea of your basic height, and a VERY rough idea of your shape. Remember to make allowances for the bits of you that aren't flat – breasts, hips, bottom – and again add extra centimetres into the equation when you get to the cutting-out stage. It's always better to overestimate and take things in, than underestimate and be unable to breathe.

■ And for experimenting with patterns, try them out with paper as your fabric and sticky tape as your thread before cutting into any material. Stick sheets of big newspaper together, draw out how you think that dress in your head should be made, cut it out, drape it around you, and pin it in place. Stand in front of the mirror, and work out where things are going right and wrong, scribble any adjustments straight onto the newspaper pattern in bright felt pen.

Scarves and Ties

There are two things that you are guaranteed to find in any charity shop, and they are big, square scarves – printed with sedate flowers or horses or neat abstract patterns or great splashes of crimson and poppy-red and pink – and men's ties. Scarves are usually very cheap, and you can tie them around the strap of your bag like French girls, or through the belt loops of old blue jeans like a cool vagabond. Wear them as a Home Counties head scarf, or around your neck like a jaunty sixties air hostess. Actually, my compulsive purchases usually end up stuffed in a drawer, and I only remember how charming they are when I come across them as I'm searching for matching socks. I'd pounce on them, thinking that they'd be lovely as flimsy summer tops, but when it came down to it, I was loath to cut them. The fabric was so fine and thin that I was worried I'd end up with a handful of frayed ribbon if I took the scissors to them. I spent a lot of time in front of the mirror with them draped across my front, or tied around my waist like an apron, trying to work out complicated ways of making them work. And then it occurred to me, why not repeat the lazy red-carpet dress method – just add a few stitches and a small row of poppers.

Scarf Tops

A Simple Scarf Top

- Put the right sides of the scarves together. Sew a 1cm shoulder seam on the left and right-hand sides 10cm in from each edge. Leave enough room for your head.
- Sew up the side seams, right sides together. Leave enough room for your arms.
- To give this top a bit of definition, you could do a couple of things, apart from tie a belt around your middle:
- Leave a gap in the side seams on both sides at about waist level. Tie a wide velvet ribbon around your back *under* the top, and then thread the ribbon through those little slits, and bring to the front, pull, and knot. This leaves the scarf nice and billowy in the back, and pulled in at the front.

Or...

- Make up the top, pull it on over your head. Grab ahold of both sides of the top at the waist, and pull them forward to the front, to form two big tucks.
- Put in a few pins to mark the place where the tucks should go.
- Sew a row of little poppers on both sides.
- Pull the top back over your head, and fasten the poppers. I like the way you get to see both scarf patterns on the front of the top and that it looks quite fitted. Again, you can play around with where you place the poppers to get different looks.

This simple scarf can also be transformed into a seductive halter-neck, with a minimum of sewing. Because the fabric is so floaty, a bit of tit tape (now known as 'lingerie tape' in more salubrious haberdashery departments) may have to be pressed into action to prevent peek-a-boob moments.

A Halter-Neck Scarf Top

- Turn over the top of the scarf, and stitch a 2–3cm hem near the finished edge of the scarf, but don't sew up the side edges of the hem...you're going to be threading the ribbon through this casing, just like a drawstring bag.
- Snip the ribbon in half.
- Then snip one of the ribbons in two and sew a length to the bottom edge of each side of the scarf.
- Attach the safety pin to the remainder of the ribbon, and pull it through the top hem so that you've got an equal length of ribbon on each side of the hem. Whip off your clothes, and tie the ribbon of the halter around your neck and tie side ribbons at your waist, pull on a pair of shorts, find your big seventies sunglasses, and slather on some high-factor sunscreen. Sunburn is never nice.

(ONE NEEDLE)
- 1 square scarf
- 300cm of wide, pretty ribbon
- 1 safety pin

And after all that I took the scissors to the scarves anyway, and used them for lining bags. It is a nice treat when you're rummaging around for your door keys to catch sight of a row of dachshunds with baleful expressions, or ladies who look like Madame Pompadour dressed for a ball. It was the same deal with ties. There they were, coiled like snakes along the wardrobe rail. I got a lot of them from my dad – dapper silk ones, and ones I'd bought him for Christmas when I was about 12 made in static man-made fibre that he pretended to like. I bought more in charity shops just because I liked the print, or because I imagined that I might, one day, wear them with a shirt with a huge collar and the most massive puffed sleeves in the world as a new sort of work uniform. But I haven't so far. Instead, I've used them as

bag straps – they look quite gallant sewn onto the sides of old cushion covers for an instant tote with a ready-installed zip. And I've undone them, and cut them into pieces and made fabric beads, pleated them into little mini corsages, or used them as silk straps for sleeveless tops. Cut-up ties also look good as cuff bracelets done up with a pretty button. This does involve making a buttonhole, a thing that used to make me feel VERY uneasy, but not any more.

Buttonholes, My *Bête Noire*

I love buttons, but for a long time I did not love buttonholes. I'd convinced myself that they were far too fiddly: why spend time looking for the special buttonhole attachment for the machine, when a row of safety pins would do instead? But then I read Dickens's description of Sally Brass's gown (in *The Old Curiosity Shop*): 'Her usual dress was a green gown, in colour not unlike the curtain of the office window, made tight to the figure, and terminating at the throat, where it was FASTENED BEHIND BY A PECULIARLY LARGE AND MASSIVE BUTTON.' And somehow it made me re-think my buttonhole attitude. Yes, they could be nice and neat, but they also could be as large as the bottom of a glass.

TOP TIP Do a trial run on a leftover scrap of fabric before making a peculiarly large and massive buttonhole in the back of your figure-hugging green dress. It's all a question of balance…too tight and you're going to have to force the button through, too loose and the button will, very annoyingly, keep coming undone. And it's definitely worth putting in interfacing behind the buttonhole; this will give the whole thing the strength to stand up to lots of doing up and undoing. Measure the length of your button before you begin and then add a few millimetres to take account of its thickness, otherwise the button won't fit through the hole.

Hey Ho, Let's Go and Make a Few Buttonholes

If you are lucky to own a very swish, very modern sewing machine, it'll do most of the work for you. All you have to do is swap the ordinary sewing-machine foot for the automatic buttonhole foot, and set it to the correct length, and away you go. If, on the other hand, like mine, you have an older machine, you're going to have to be more involved in the process.

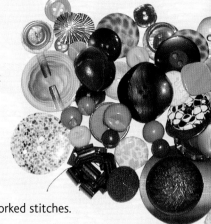

- With tailor's chalk, mark on the fabric where you'd like the buttonhole to go.
- With my machine, you have to swap the ordinary foot for the zigzag one, and change the stitch selector four times (see below) to make a buttonhole, but it's worth checking your machine's manual to see what they recommend, in case it's different.
- Set the stitch selector; sew down the left-hand side.
- Change the stitch selector, and sew along the bottom of the buttonhole.
- Change the stitch selector, and sew up the right-hand side.
- Change the stitch selector, and sew along the top of the buttonhole.
- Then cautiously slash the middle without snipping all those carefully worked stitches.

 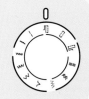

Felt

I also L.O.V.E. felt. It comes in loads of different colours, doesn't fray, and is very cheap. It's great for appliquéing leaves, tower blocks and monsters. Discs of contrasting shades can be sewn or glued to T-shirts and skirts. And squares can be whipped into a cute evening bag while watching *What Ever Happened to Baby Jane?* as inspiration for the old lady you'd secretly like to turn into – bonkers, murderous, bad make-up. It takes a few minutes to transform a strip of felt into a sea anemone corsage or a furled-leaf chrysanthemum. You can cut out big, bright flowers, and add a button to the front and a brooch back to the back, and pin it to the lapel of an old-rose velvet jacket. Or make up miniature felt pictures sewn onto a couple of layers of felt and threaded onto a length of glittery wool to make a necklace or bracelet. Or bold triangles and squares of colour can be sewn with BIG stitches to the shoulders of Tees for a nice abstract look.

The only flaw with felt is that it really should be dry-cleaned – hand-washing can make it lumpy and bumpy. But it is so cheap (about 60p for a small square) that it's just as easy to start again.

Make Your Own Felt

(First, Steal Your Brother's Jumper...)

Another good thing to look out for in charity shops, or to scavenge from your dad/boyfriend/brother, are old, big, baggy, 100% wool jumpers. It doesn't matter if they are a bit tatty at the elbow and neck, as you're not going to be wearing them immediately. First, you're going to apply some hot-as-the-hob-of-hell water.

■ Old 100% wool jumpers
■ Pillowcases
■ 1 pair of old jeans

■ Bung the jumpers into pillowcases, and then put them in the washing machine, with a pair of old jeans for good measure (they don't need to be in a pillowcase).

■ Set the temperature to 60 degrees and the dial to the longest wash cycle, and wash the jumper bundles with some gentle washing powder.

■ Don't overload the machine; you want the jumpers to be swooshed around a good bit. The pillowcases will stop all the unravelling bits of wool from clogging up the machine; the jeans just add to the agitation. Wool plus heat plus agitation equals lovely felted wool, a nice, thick, strokable fabric that won't fray. (This is not a recommended treatment for heirloom cashmere, but old 100% wool blankets, skirts, even coats can be shrunk and felted.)

Sometimes happenstance and washing powder can make the ginormous jumper into a slinky piece of knitwear, now deliciously cropped at the waist and wrist. More likely what you'll have is an interestingly textured bumble of fabric, which can be transformed into corsages and bags, or cut into a little shoulder cape.

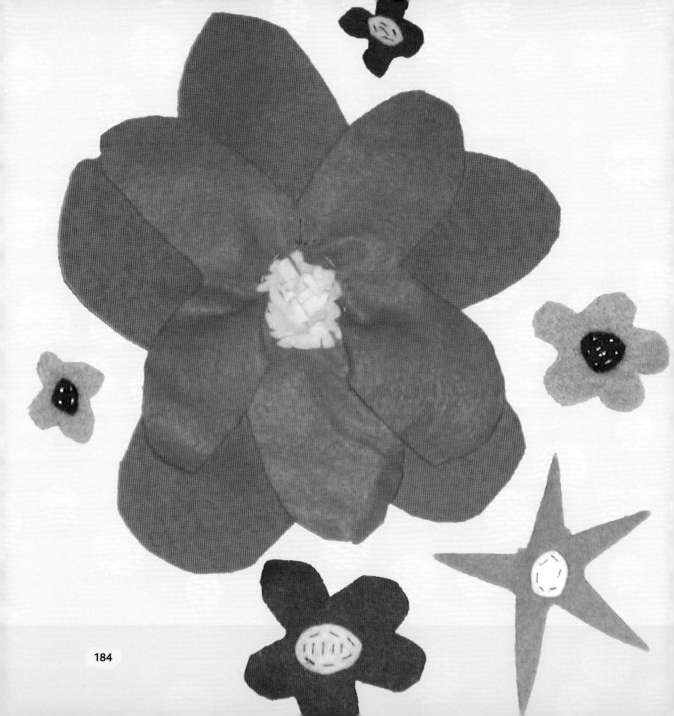

Quick Felt Flowers

✿ Cut out two flower shapes and a different-coloured middle.

✿ Glue or sew the pieces together.

✿ Sew on the brooch back; attach it to the strap of a shoulder bag.

(ONE NEEDLE)
▨ Scraps of different coloured felt
▨ 1 brooch back

You could also cut out the same big, bold flower shape from the felt and a contrasting fabric, some tweed maybe or velvet or netting, layer the pieces together, and attach a brooch back to the back for an instant stand-out accessory. Make another flower, and attach it to a velvet ribbon for a Moulin Rouge choker, or add a large flower to a wide length of satin ribbon for the perfect belt for a tea gown.

A Sea Anemone

I found a book in a second-hand book shop of underwater photographs from the Great Barrier Reef, and when I open it up I feel in love. There are pretty strange things living in the deep, and some strangely pretty things too. Ghost pipe fish, pincushion sea stars, colourful sea slugs and pink and lilac nudibranchs. I tried to make a nudibranch out of cut-up tentacles of felt threaded onto glittery thread, and this handmade sea anemone is quite lovely too.

(ONE NEEDLE)
■ 2 x 24cm x 8cm strips of felt
■ 1 brooch back
■ Beads or sequins

- ☐ Cut a skinny 6cm fringe along one of the long sides of one of the strips of felt. The 2cm that you haven't cut is going to be the stalk of the sea anemone.
- ☐ Do exactly the same with the other bit of felt.
- ☐ Roll up the first fringed strip as tightly as you can.
- ☐ Wrap the second strip around the first in the same way.
- ☐ Wind a length of bright thread round and round the anemone's stalk, so that the fronds can droop without the whole thing unravelling. Sew or glue a brooch back to the bottom of the sea anemone, and beads and sequins to catch the light. Pin it to a dress the colour of the ocean.

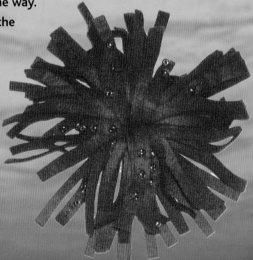

A Chrysanthemum

Makes a medium-sized flower.

- Fold the felt in half lengthways.
- Cut a fringe through the fold, stopping 1.5cm from the edge.
- Roll up the stem.
- Wind a length of bright thread around the stem to stop the flower from unravelling.
- Sew the leaves onto either side of the stem.
- If you want, sew a button from your button jar into the middle of the flower.
- Sew a brooch back to the base of the stem.

(ONE NEEDLE)
- 14cm x 9cm of felt
- 2 green felt leaves
- 1 pretty, round button (optional)
- 1 brooch back

Make them in lots of different sizes and colours to create a flower necklace or bracelet. Or use roughly the same technique to make...

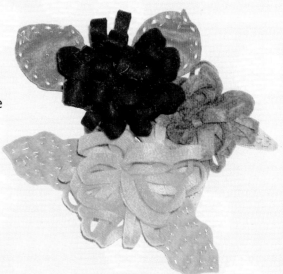

A Strand of Felt Lanterns

- Take the pieces of felt, and zigzag the long edges in a contrasting colour of thread (for purely decorative purposes).
- Fold each piece in half, and cut a fringe across the fold, but don't cut all the way to the edge.
- Unfold them, and then furl them into lantern shapes, and sew the sides together.
- Sew some thread across the tops for handles, and then fasten them along three strands of plaited ribbon or thin leather cord.

(ONE NEEDLE)

- Several pieces of felt, each about 8cm x 4cm
- 3 strands of plaited ribbon or thin leather cord

A Small Headpiece

- Put a line of running stitches around the centre of each of the flower shapes and around the fringed circle, leaving a long tail of thread at the end.
- Tug on the tail of the thread, so that the fabric scrunches up into a flower shape.
- Use the tail of thread to keep the flower scrunched up by sewing a few stitches at the back of the flower.
- Sew the two flowers together, and then sew the fringed bit in the middle.
- Sew the whole flower to the comb.
- Add long wispy feathers and a bit of net if you feel like it.

(ONE NEEDLE)

- 1 biggish piece of felt and 1 medium bit of felt, cut into flower shapes
- 1 smaller circle of felt, with the outside edge cut into fringes
- 1 piece of net (optional, but John Lewis do some lovely stuff called 'Merry Widow' net, and it's about £1.50 a metre)
- 1 cheap plastic hair comb (not the kind you comb your hair with, the sort that you use to keep the hair out of your eyes)
- Some feathers (optional)

And you can make more lovely hair ornaments with a little heap of felt flowers: small animal shapes, butterflies, nice sparkly beads, sequins. First, go for a quick wander to your local chemist's or supermarket, and head for the stand that stocks those plastic rain hats for 99p. Put one in your basket: they are always handy to have. Maybe throw in another couple of side combs to make spring-wedding headpieces, then add chignon pins, which cost about 90p, and those snippy-snappy hair clips, which are about £1. Go home. Cut out your chosen shape and fabric, glue the beads and sequins to the felt. Sew the shapes to the pins and clips. Sprinkle them liberally in your hair.

A Slashed Scarf

And with felted wool or plain ordinary acrylic felt, you can get scissor happy and make a nice slashed scarf.

- Get a length of felt, fold it in half lengthways and make a series of angled slashes along the fold.
- Open the scarf out, and sew sequins in between the slashes.

(ONE NEEDLE)
- 1 piece of felt (whatever dimensions you wish your scarf to be)
- Sequins

A Spring Wrap

Remember spending hours snipping away at bits of folded-up paper to make snowflakes on a wintry evening? You can apply the same technique to another long piece of felt for a spring wrap.

(ONE NEEDLE)
▨ 1 piece of felt (whatever dimensions you wish your wrap to be)

✳ Fold a fairly big bit of felt in quarters, and then cut your pattern out on the fold, maybe have a bit of a practice on a small bit of felt first, until you get good.

If the miniatures look nice, you could also sew them on little squares of fabric, and turn them into elegant silhouette brooches.

Knit Girls

How to knit legwarmers, arm gauntlets, a snug collar and many other woolly wonders

I don't exactly remember the first thing I knitted, but I'm betting it was a scarf with big holes from dropped stitches and wonky sides from where I accidentally increased or decreased. I have phases of not looking at anything woolly for ages and then going completely bonkers and knitting non-stop everywhere. There is something addictive and funny about twisting yarn around needles and ending up with a jumper. That said, I never do anything complicated. I just stick to easy shapes and bright colours and medium or big needles. My friend Helen knits on pins with Lurex and thread: silver spaceships with tiny aliens waving from the windows of their flying saucer, green-gold dragons and miniature teddy bears with complicated Aran or Fair Isle jumpers. If you hold a magnifying glass up to them, the details are perfect: tiny twisted cables, teeny snowflakes and fir trees. And she knits them on pins. PINS! I know I won't be going down that meticulous route at any time, but I can guarantee that I'll be making something that closely resembles Holly Golightly's knitting efforts in *Breakfast at Tiffany's*.

Pompoms

I L.O.V.E. pompoms! Tiny ones in soft, soft wool to decorate a necklace, medium-sized ones to grace gloves or a scarf or a handbag. I especially like HUGE pompoms, the sort that on a knitted hat would overbalance a small child. All that, and you don't even have to concentrate to make them.

- Wool in different colours
- The thin cardboard from cereal boxes
- Your sister's compass and protractor set, or a teacup from the kitchen cupboard

- Draw two circles on the card, and then draw two smaller circles in the middle of each of the bigger circles, about half the size of your first circle.
- Cut the big circle out, and then cut the smaller one out.
- Get some yarn, and tie it around the middle of the two circles, and then start winding the yarn around and around and around until the middle is full.
- Snip around the yarn between the two rings.
- Gently pull the two rings apart, and tie a strand of yarn tightly around the middle, leaving a good dangling bit of yarn.
- Fluff up your pompom, add to a jumper or mittens, or make a necklace in different colours and bright yarns to grace the neckline of a dark dress or coat.

Buy one of those bobbins shaped like a little wooden person (they cost about £3), and do a huge line of French knitting to make the braided chain of your lovely necklace. Or make a few HUGE pompoms, about the size of allium blooms (aka ornamental onions), and sew them onto a thin piece of stocking stitch (which I'll explain about in a little bit) as a scarf. Or make quite a few medium pompoms, and attach them together for a Pierrot-style neck warmer.

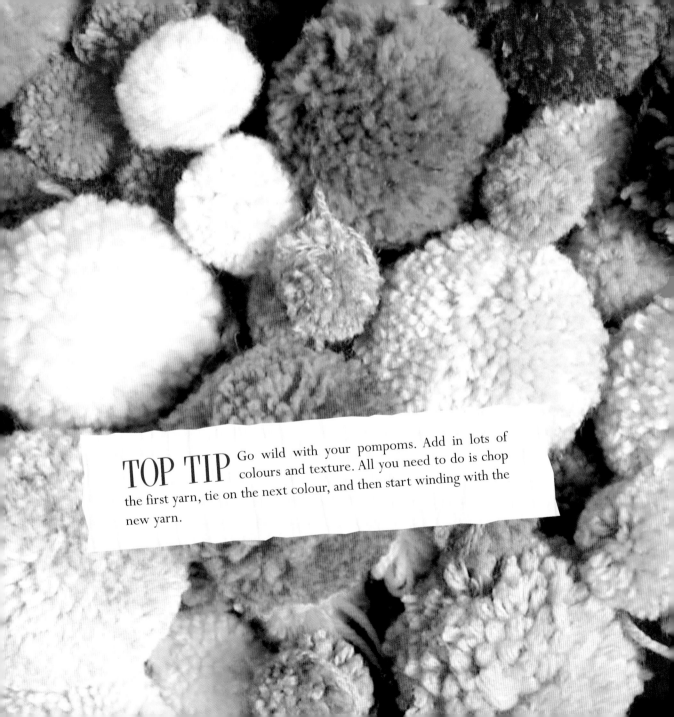

TOP TIP Go wild with your pompoms. Add in lots of colours and texture. All you need to do is chop the first yarn, tie on the next colour, and then start winding with the new yarn.

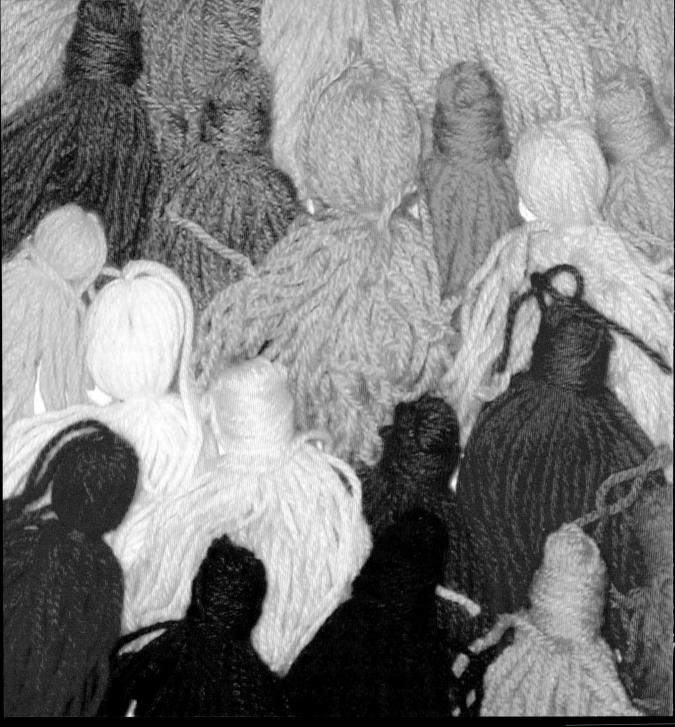

Tassels Are Nice Too

- Wind the yarn lots of times around a CD case or a book of Snoopy cartoons or a piece of card.
- Cut it carefully at one end.
- Get another longish piece of yarn, and tie it tightly under the uncut ends.
- Wrap the dangly bit of yarn around the tassel to secure it. Use the rest of the yarn tail to sew it on.

■ Wool in assorted colours
■ 1 CD case, thin book or piece of card

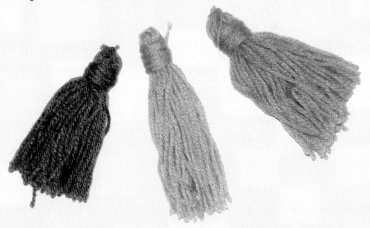

How to Knit

Get a pair of no. 4.5 needles and a 100g ball of very cheap acrylic knitting yarn in a nice, bright colour. Go for a yarn that's Double Knitting (DK) too...anything finer is going to be too fiddly at first. It's better to choose a vivid colour rather than black or navy blue because it's much easier to see the stitches and where you're going right and where you're going wrong.

How to Cast On

(Otherwise Known as Getting Stitches Onto Those Needles)

First, you've got to make a slip knot. If you can already do that, skip the next few sentences; if you can't, here goes...

- Get a ball of yarn. Unwind about 20cm. Let that bit dangle between the thumb and first finger of your left hand.
- Wrap the ball end of the yarn around your first finger in a clockwise direction, not too tightly though.
- Then pull a loop of yarn through the loop on your finger.
- Slip it off your finger, and slide that loop onto your needle.
- Tug on both bits of yarn to tighten the knot, but not too tight. Hurray, that's the slip knot done, and your very first stitch.

Needles at the ready?

❶ Slip your right needle into the first stitch on your left needle, from front to back, with the right needle under the left.

❷ Wrap the yarn around the right needle.

❸ Slide the right needle back, so that the tip of the right needle catches the loop of the wound-around yarn.

● Draw this new loop of yarn towards you through the previous stitch.

❹ Slide that new loop off the tip of the right needle onto the left needle.

❺ Put the right needle between the two stitches on the left needle.

● Wrap the yarn around the right needle.

● Draw that new loop towards you in between the two stitches.

● Slide that new loop off the tip of the right needle onto the left needle.

● Put the right needle between the last two stitches on the left needle.

● Wrap the yarn around the right needle...Keep on going just like this until you have made the desired number of stitches...14...144...1,444...14,444...

How to Knit a Row

(in Garter Stitch)

So there are all your new stitches looking pert and perky on the knitting needle. The next thing to do is to start knitting them.

● Slip your right needle into the first stitch on your left needle, from front to back, with the right needle under the left.

① Wrap the yarn around the right needle.
② Slide the right needle back, so that the tip of the right needle catches the loop of the wound-around yarn.

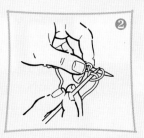

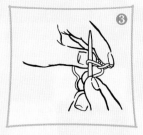

❸ Draw this new loop of yarn towards you through the previous stitch. Bring the right needle forward, with the new loop still on the needle, so that the right needle rests across the top of the left.

● Keeping the new loop on the right needle, slide the old stitch off the left needle.

● Put the right-hand needle into the next stitch on your left needle...and repeat what you just did. You are now knitting in garter stitch.

How to Purl

A lot of knitting is just made up of a combination of two basic stitches...you've got garter under your belt, now all you need are some purls.

● Hold your needles in the same way as for garter stitch.

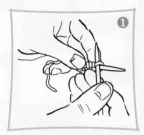

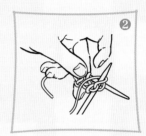

❶ Slip your right needle into the first stitch on the left needle, from back to front, with the right needle on top of the left.

❷ Wrap the yarn around the right needle anticlockwise.

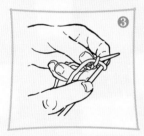

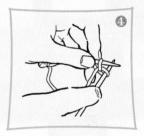

❸ Slide the right needle tip down to catch the new yarn loop.

❹ Push this new loop away from you through the old stitch, so that the right needle is behind the left.

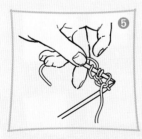

❺ Slide the old stitch off the left needle, keeping the new stitch on the right needle.

● Slip your right needle into the first stitch on the left needle, from back to front, with the right needle on top of the left needle...and repeat what you just did. You are now purling.

And now you need to know how to stop, unless have entered a competition to knit the world's first never-ending scarf.

How to Cast Off

- Knit the first two stitches on the row.

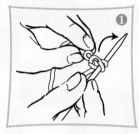

 ❶ Slip the left-hand needle into the first stitch you knitted on the right needle, and pull it over the second stitch you knitted, letting it drop off the tip of the needle.

- There now should be only one stitch left on the right needle.
- So knit another stitch from the left needle, and pull the first stitch over the new one.
- Keep going 'til you have one lonely little stitch left.

- Cut the yarn about 20cm from that lonesome stitch, and pull it through the last stitch. Give it a gentle tug.
- *Et voilà*, the longest scarf in the world is now finished, and you can head out to the shops wrapped up like a woollen mummy.

How to Do Stocking Stitch

One of the best-loved combinations of knit (garter) and purl. Just knit one whole row and purl the next, then knit a row, then purl a row...keep going like that.

How to Do Moss Stitch

I love the look of moss stitch (also known as seed stitch). Once again, it's a combination of garter and purl stitches that make little goose bumps when you knit them. You make it by knitting one row of K1, P1, K1, P1 (knit one, purl one, etc.), and then on the second row, you P1, K1, P1, K1. For this to work you must have an even number of stitches.

A Bright-Pink Belt

- Cast on ten stitches.
- Knit loads of rows in garter stitch.
- Cast off when you get to a length you like the look of.
- That's it. Tie it around your waist.

(ONE NEEDLE)
- 50g ball of bright-pink yarn
- 1 pair needles (no. 4.5)

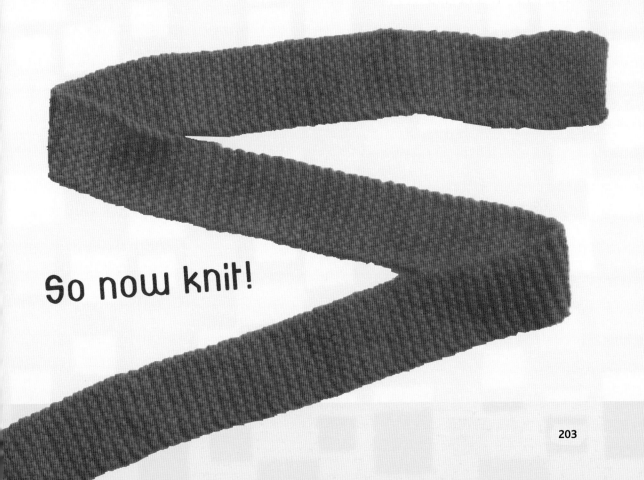

So now knit!

A Knitted Collar

Put the cheap acrylic aside, head to the yarn shop, and pick one ball of something in a beautiful shade that feels lovely 'n' soft and is **VERY EXPENSIVE**. A chunky yarn, like Rowan Big Wool, is best.

- Cast on about ten stitches.
- Knit in garter stitch until your strip reaches about 40cm.
- Cast off.
- Attach two little lengths of velvet ribbon, one to each side.
- Maybe add a couple of buttons.
- Tie it around your neck.

Really, Really Easy Fingerless Gloves With No Shaping Whatsoever

There's a little ribbed cuff on the bottom of each of these mitts. Rib is a nice stretchy combination of garter and purl stitches. Make them in a lovely colour — cherry red or periwinkle blue.

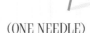

(ONE NEEDLE)
- 50g ball of Double Knitting yarn
- 1 pair of needles (no. 4)

※ Cast on 32 stitches. Leave a nice long dangly bit of yarn at the beginning of the stitches, which is going to come in handy later to sew up the glove.

※ Add more stitches for a larger mitt, in multiples of two...so 34, 36, 38...

※ Get ribbing...K2, P2...for 10 rows.

※ Swap to stocking stitch...one row of plain, one row of pearl...for 42 rows.

※ Switch back to rib for five rows.

※ Cast off.

※ Turn that mitt inside out, and start sewing up the side seam with that dangling bit of yarn. Leave a gap for your thumb to poke through. Finish off sewing the side seam.

※ Admire your handiwork, and then start another pair that are a bit more fancy...Add stripes in bright colours and some glittery yarn to make running-away-to-the-circus mittens. Make a matching scarf in garter stitch decorated with buttons, and sign up for trapeze lessons.

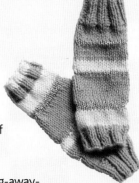

205

Knitting Stripes

Here's how to get stripey...

- Start with one colour...it's best to do the rib in the same shade and then swap colours when you get to the stocking-stitch bit. Add in your new colour at the start of a row.
- Don't start at the beginning of the ball – begin about 15cm in – and just start knitting.
- The first stitch is going to be a bit floppy, but just keep going...until you've knitted about eight stitches and stop.
- Go back to the start of the row, and tie the yarn together to keep it from undoing. That knot's not going to be there for ever; when you come to sew the mitt up, undo it, and sew the ends into the knitting to make it all neat and tidy. Carry on knitting to the end. Knit another row...there's your first stripe.
- Knit one more row if you want a skinny stripe, and a good few more if you want a chunky band of colour.
- Lurex is thinner than the Double Knitting yarn and a bit slidey to knit with, but it looks nice and sparkly against the matte colours, so keep on going.
- Add in other stripes when you feel like it...cut one colour, not near the last stitch 'cos all your hard work will undo, but leaving a 15cm dangle, and attach a new shade just like you did before.

- Small selection of bright yarn (For the top mitts on page 205 I used some acrylic that I had lying around in turquoise blue, bright pink and a nice, sedate sage green, and some silver metallic yarn or gold Lurex shimmer, and just played around with the colours.)
- 1 pair needles (no.4)

TOP TIP If you're going to be knitting thin stripes, instead of chopping the yarn every time you change colours, just let the colour you aren't using dangle alongside your work. Every time you get to the end of the row where this yarn is dangling, twist it once with the yarn you're knitting with – this'll keep this resting colour in place for when you want to kick it into action.

A Knitted Flower to Sew Onto a Jacket

- ✿ Cast on 3 stitches.
- ✿ Knit 2 rows.
- ✿ Increase 1 stitch at the beginning of each row until there are 8 stitches.
- ✿ Knit 9 more rows on those 8 stitches.
- ✿ Decrease 1 stitch at the beginning of every row until there are 3 stitches left.
- ✿ Knit 2 rows.
- ✿ Knit 9 more rows on those 8 stitches.
- ✿ Decrease 1 stitch at the beginning of every row until there are 3 stitches left.
- ✿ Cast off.
- ✿ Knit one more elongated petal in exactly the same way.
- ✿ Sew into a flower shape. and stitch a pretty button in the middle of the knitted petals.

(ONE NEEDLE)
- ◼ Odds and ends of Double Knitting yarn in flowery colours
- ◼ 1 pair of needles (no. 4)
- ◼ A button

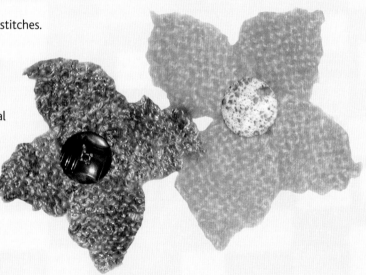

A Ribby Snood

- ✳ Cast on 167 stitches.
- ✳ First rib row: K1, P1, K1, P1 all the way to the end. The last stitch should be a knit.
- ✳ Second rib row: P1, K1, P1, K1 all the way to the end. The last stitch should be a pretty purl.
- ✳ Repeat the last two rows until your knitting measures about 45cm.
- ✳ Sew up the side seams.
- ✳ Add pompoms or tassels and a sprinkling of sequins.

(ONE NEEDLE)

- ▨ 200g ball of Double Knitting yarn
- ▨ 1 pair of needles (no. 4)
- ▨ Pompoms, tassels or sequins

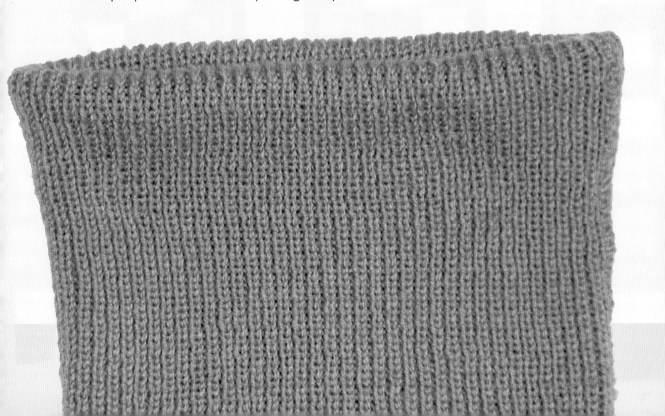

A Knitted Collar with Three Buttons

- Cast on 30 stitches.
- Work 20 rows in moss stitch...K1, P1, and then reverse it at the start of the next row...P1, K1. Then repeat the first row.
- Then knit three rows in garter stitch in the main colour. Keeping knitting in garter, but put in stripes whenever you feel like it.
- Knit a further 48 rows in garter stitch.
- Then three more rows in garter stitch in the main colour, before going back to moss stitch.
- Make the buttonholes on row 16 of this moss-stitch section.
- Here's how: knit four stitches, cast off three, knit four, cast off three, knit eight, cast off three. Moss to the end of the row.
- On the next row moss-stitch along the row 'til you come to the place where you cast off the stitches.
- Then swap the needles. Put your right-hand needle in your left hand and the left needle in the right, so that your work looks the wrong way round.
- Cast on the same amount of stitches that you cast off. And then swap your needles back and moss 'til you come to the next lot of cast-off stitches.
- Knit two more rows of moss stitch and cast off.
- Find three nice buttons from the button jar and sew them on. You can wear this collar with the nice clean-edge stripes facing outwards, but I like the other side better...I think it looks prettier and more blurry.

(TWO NEEDLES)

- 50g ball of Double Knitting yarn in the main colour
- 1 pair of needles (no. 4.5)
- Odds and ends of other Double Knitting colours to work some stripes
- 3 nice buttons

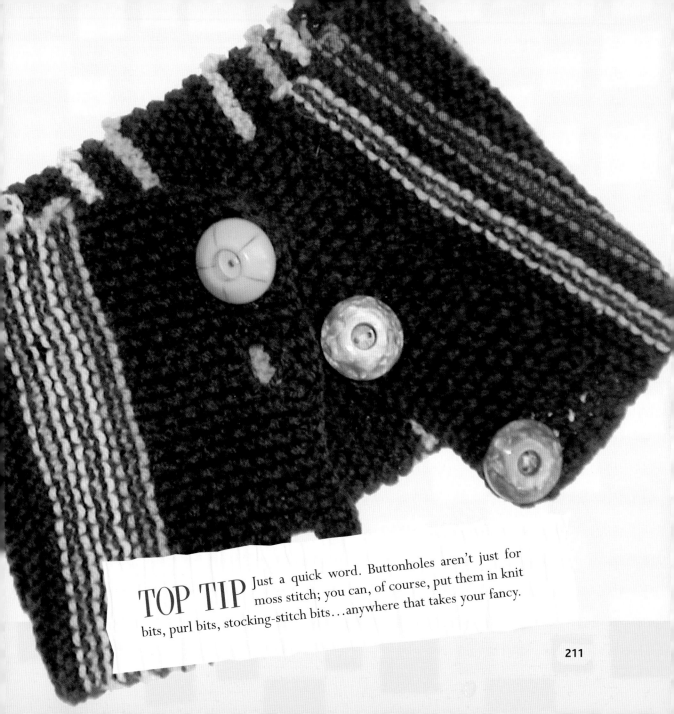

TOP TIP Just a quick word. Buttonholes aren't just for moss stitch; you can, of course, put them in knit bits, purl bits, stocking-stitch bits…anywhere that takes your fancy.

A Scarf That Looks Like a Christmas Decoration

Plus a bit of practice with increasing stitches and decreasing stitches.

★ Cast on four stitches. Knit them.

★ Now turn those four stitches into five. Here's how: knit a stitch, and then with the right needle pick up that little strand of yarn that's resting between the stitch you've just knitted and the one you're about to knit, and put it onto your left needle. Put the right needle into the BACK of the stitch, and knit it. It's going to be a bit tough, but keep going; you'll have a new, invisible stitch. If you knit into the front of the stitch, you'll have a new stitch but with a big hole.

★ Knit to the end of the row. On the next row, add another stitch so five grows into six.

★ On every row add another stitch 'til you reach 26.

★ Knit one row without doing anything.

★ Now start decreasing. Here's how: knit one, and then knit the next two stitches together.

★ On every row take away a stitch until you're left with four.

★ Knit a row.

★ Now start adding a stitch to each row until there are 26 again.

(TWO NEEDLES)

■ Assorted yarn (I used VERY cheap acrylic yarn and some quite expensive Lurex, but you could use anything that you like the look of. I'd go for a yarn that knits up on no. 4 needles plus…anything finer is going to take about a year to make. Also fine yarn won't get you the rippled crêpe-paper effect that makes you think of pine-needle carpets and snowballs — both sorts, the alcoholic ones and the ones made of frozen water.)

■ 1 pair needles (no. 4 or bigger)

★ Knit a row.
★ Now start taking away a stitch every row until there are four.
★ Knit a row.
★ Now start adding a stitch every row until there are 26...you get the picture.
★ Keep on keeping on until you have a huge swage of diamond shapes to deck over a coat the colour of a Christmas tree.

You can make this scarf big and chunky by using no. 8 needles, doubling the amount of yarn and twisting two strands of Double Knitting yarn together. Start with two stitches, and then increase in exactly the same way as above until you have 16 stitches. Decrease in exactly the same way.

Legwarmers and Arm Gauntlets Inspired by Princess Mononoke

Princess Mononoke is one of my favourite screen heroines. You can't beat a fierce girl raised by wolves and in tune with forest spirits.

The palette for Princess Mononoke is deep purple-blue with a plum stripe and strangely pretty. To transform these into slapdash disco-slut accessories, be lavish with the colour, drop a load of stitches, and be very liberal with big paillette sequins.

- 150g of purple-blue Double Knitting yarn for the legwarmers
- 1 pair of needles (no. 4)
- A scrap of alternative colour to work a stripe (Disco sluts are going to need shades less subdued, but in similar quantities.)
- 1 pair of needles (no. 4.5)
- 50g of purple-blue Double Knitting yarn for the arm gauntlets.

Legwarmers

- Cast on 55 stitches with the no. 4 needles in your main purple yarn, and work a rib row: K1, P1 all the way across.
- Row two: P1, K1 all the way across.
- Alternate these two rows until the rib measures 8cm, ending with a first row.
- Then Rib 2, *M1 (make one), Rib 5*. Repeat the starry instructions all the way across the row, until you come to the last 3 stitches. M1, rib to the end. You now should have 66 stitches on your needle.
- Switch to no. 4.5 needles, and the stripe colour (disco sluts, do your own thing), and work eight rows in stocking stitch, starting with a knit row. Ditch the stripe, and embrace the main colour.
- Continue in stocking stitch until the legwarmer measures about 38cm, ending with a purl row.
- K2, *K2tog (knit two together), K4 *. Repeat starry instructions up to the last four stitches. K2tog, K2.
- Switch to no. 4 needles, and knit 8cm of rib, starting with a second row.
- For the last two rows, go back to the stripey colour, and cast off loosely in rib.
- Make another legwarmer to match.
- Sew up the side seam of each legwarmer.

Arm Gauntlets

- Cast on 35 stitches in purple-blue with no. 4 needles.
- Do the same rib as for the legwarmers until it measures 8cm.
- Next row: Rib 4, *M1, Rib 9*. Repeat starry instructions until the last four stitches. M1, rib all the way to the end. You should know have 39 stitches on your needle.
- Switch to no. 4.5 needles and the stripey colour, and stocking-stitch and knit eight rows starting with a knit row.
- Ditch the stripey wool, and head back to the purple. Keep stocking-stitching until the whole thing measures 18cm ending with a purl row.
- Next row: K4, *K2tog, K8*. Repeat starry instructions across the row, until you get to the last six stitches. K2tog, K4. You should now have 35 stitches on your needle.
- Swap to no. 4 needles and rib, just like you did for the legwarmers until the rib measures 8cm. Then for the next two rows, work in the stripey colour, and cast off loosely in rib.
- Make another arm gauntlet to match.
- Sew up the side seams on each of the gauntlets.

If inspired by Princess Mononoke, head into the forest, look for spirits, and, in your arm gauntlets and legwarmers, dance beneath the light of the moon. Disco dollies, head for Cinderella's nightclub, drink spirits, and dance beneath the sparkle of a glitter ball.

A Good Time to Talk About Tension

On knitting patterns there's always a little section that says something like '28 stitches and 36 rows to 10cm measured over stocking stitch using no. 4 needles and Double Knitting yarn', and it is tempting to just go right ahead and ignore that as too much information, which is exactly what I did when I made the ginormous purple gloves. I just got the yarn out and started, and ended up with a giant's knitwear. What I should have done was worked that little tension swatch first. If you are about to embark on a jumper or a cardie, or something that's going to take a long time to make, you are going to want it to fit pretty much perfectly in return for months of hard work and sore fingertips. The way to ensure a fairytale ending is to knit at least a 10cm square with the needles and the exact yarn, or a close match that the pattern suggests. Don't press this piece of knitting, but put it down on a nice, hard, flat surface, and get the

ruler out (don't use a tape measure, it's a bit too stretchy), and head for the centre of your swatch. Measure out the 28 stitches across the knitting, and the 36 rows. Put pins in to keep track. If your swatch measures up, then you can go right ahead. If your square is too small, work another square with bigger needles; if too big, switch to smaller needles until you get it just right, that way there will be no size mishaps.

Don't bin those tension swatches. Piece them together and make an avant-garde garment. Need inspiration? Look at the knitwear of Claire Tough, whose dresses and sweaters are a delicious mish-mash of contrasting colours, textures and stitches; every dress is a knitting adventure.

And don't restrict yourself to neat needle sizes...buy needles that are as rotund as cannelloni, use fat yarn, and cast on a bunch of stitches...and get to work on a big raucous rectangle. Progress will be fast and fun. Knit in buttonholes all the way around...then the oblong can become a shrug, a wrap, an asymmetrical cape, a symmetrical cape, a woolly skirt...Add spangles for a froufrou feel.

Epilogue

How to make a draught excluder in the shape of a sausage dog in 17 weeks

WEEK 1
Assemble the necessary supplies.

100cm of 150cm-wide fabric (Brown needle-cord will give a very naturalistic effect; pale green needle-cord will make your dachshund look like a small, elongated dragon, which is not a bad thing.)

Squares of felt for ears, nose and red tongue

Far too many bags of Kapok stuffing

100cm of ribbon for the dog's collar

2 pretty buttons for the doggie's eyes

WEEK 2
Design your dachshund.

WEEK 3
Cut 20cm from the 100cm, and attempt to make the dog's head. Tricky. Abandon that for the moment, cut a few more centimetres from the 100cm, and make the tail instead.

WEEK 4
Turn the felt squares into a little evening handbag with a ribbon tie. Buy more felt. Buy more ribbon.

WEEK 5
Make an A-line skirt in autumnal needle-cord. Decide that maybe a pale green dog would be nicer than a brown one. Buy some pale green fabric.

WEEK 6
Open the bags of Kapok stuffing, just to see what it looks like. Create a winter landscape with a Kapok snow blizzard.

WEEKS 7, 8 AND 9
Clear up the winter landscape. Hire a snowplough.

WEEK 10
Start making the body of the sausage dog. Fold the fabric in half lengthways, right sides together, and sew 1cm in from the edge all the way along. Breathe in a stray bit of Kapok and have a sneezing fit. Get the quick unpick, and undo the crooked seam that you have just sewn.

WEEK 11

Think about re-making the body of the sausage dog. Decide to transform the ribbon into a rosette. Nip out to the shops and buy some wide velvet ribbon, sew the ribbon rosette to the velvet for an instant, elegant choker. Buy some fake suede cord to use as a collar instead.

WEEK 12

Sew up the body of the sausage dog. Sew the tail on one end, any old how. Turn the dog the right way out.

WEEKS 13 AND 14

Attempt to make a realistic dachshund's head by trimming the fabric into shape. Don't worry if it's a little lopsided. Turn the leftover scraps of material into fabric beads, and sew them onto a length of fake suede cord. Make a matching bracelet with a little scrap of fabric, use the two buttons to fasten it, decorate it with the felt, cut into leaf, flower and berry shapes.

WEEK 15

Have second thoughts about the dachshund.

WEEK 16

Stuff the dog. Try not to think of sausages as you do it. Make some haphazard doggy features, and sew them onto the dog. Stitch the head in place.

WEEK 17

Find a draught for the skinny sausage dog to perch in front of.

BIG THANX TO:

Chris Harvey, Kathleen, Una and John Farry, Lesley Owen, Ciaran, Niall, Sean and Keelan McDermott, Kathyrn Holliday, Sarah and Helen O'Mahoney, Elizabeth Price, Rachel Larkins, Matthew Thompson, Gregory Webster, Amelia, Rob, Dora and Ivy, Craig Longmuir, Phoebe Blatton, Abby Cocovini, Seraphina Anderson, Rachael Matthews, Rosie, Harriet and Amy at Tatty Devine, Helen Coyle, Philip Gwyn-Jones, Karen Duffy. Helen, Kelly, Emma, Mark, Jess, George and all at Weidenfeld and Nicolson, Patrick Carpenter at Nova White, and Richard Carr.

The book was inspired by the ultimate DIY motto from *Sniffin' Glue* fanzine:
'This is a chord.
This is another.
This is a third. Now form a band.'
Swap chord for stitch, and you end up with a dress,
not The Clash.

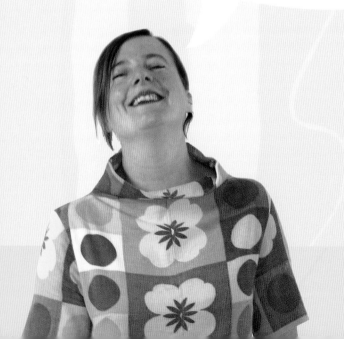